# TEDDY BEARS

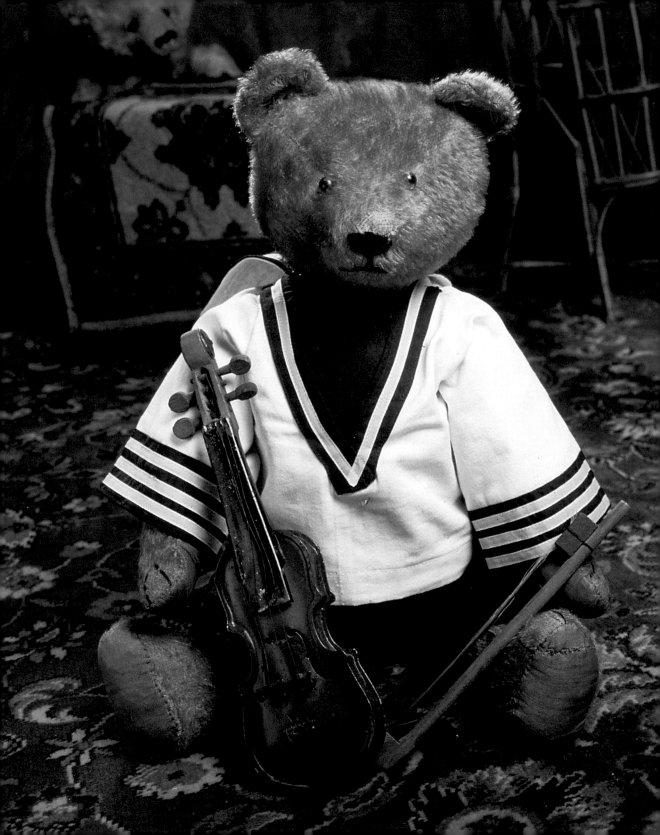

# Teddy Bears

## Mirja de Vries

**TASCHEN**

KÖLN LISBOA LONDON NEW YORK PARIS TOKYO

# TEDDY BEARS

Fluffy or tatty, brown or beige or black, teddy bears have won countless millions of hearts in their ninety-year history. Often they can be cuddly friends for life – and those special bears are the preferred subjects of well-known teddy bear photographer Mirja de Vries. As long as they're unique old bears with the telltale wear and tear of cuddlesome affection about them, it doesn't matter if they're lop-sided or missing an ear. What counts is that they be alive. Mirja de Vries has the rare gift of making teddy bears talk to us.

Back in the days when she was studying graphic design and photography, she published a highly-regarded book about a dead duck, and in 1975 Knuffels, her first book on soft toys, followed. Since the Eighties she has devoted her attention to teddy bears, and her photographs can now be seen on countless posters, postcards and calendars.

"Photographing bears isn't easy – you must have a feeling for them, otherwise it's pointless. I really love

the old Steiff bears, the ones with the pointy noses and sturdy arms and legs. They have a special air about them, but I can still fall for your common or garden bear too. The world of bears fascinates me; I've been photographing them for eighteen years now, apart from a few breaks in between, and I'm still not tired of looking at them."

All Mirja's pictures reveal a magical secret – the inner life of her bears. Whatever the pose, the inspiration is always the bears' individual characters, from the roguish to the aristocratic, from the sailor or mountain climber to the chivalrous knight. With a whimsical imagination altogether her own, the dedicated Mirja de Vries has produced photographs that eloquently say what so many know – that teddy bears (and photographing them) are fun.

# TeddyBären

Ob flauschig oder abgewetzt, ob braun, ob beige, ob schwarz – der Teddy hat im Laufe seiner neunzigjährigen Geschichte Millionen Herzen erobert. Oft begleitet er seine Fans ein Leben lang. Solche Bären sind die Lieblingsmodelle der bekannten Teddy-Fotografin Mirja de Vries. Sie müssen vor allem alt und einzigartig sein: Jemand muß mit dem Bär geschmust haben, an ihm gehangen haben, er darf krumm und schief sein, ihm kann das linke Ohr fehlen. Das macht alles nichts, Hauptsache er ist lebendig. Mirja de Vries bringt die kleinen Tiere auf ihre Art zum Sprechen.

Bereits während ihres Grafikdesign- und Fotografie-Studiums gab sie einen vielbeachteten Band über eine tote Ente heraus. 1975 erschien der Bildband Knuffels, ihr erstes Buch über Kuscheltiere. Seit den 80er Jahren hat sie sich ganz auf Teddybären konzentriert, und ihre Fotos schmücken inzwischen zahlreiche Postkarten, Poster und Kalender. „Es ist gar nicht einfach, Teddybären zu fotografieren. Man muß schon ein ganz

besonderes Verhältnis zu ihnen haben, sonst geht es nicht. Ich mag vor allem die alten von Steiff sehr, die mit den spitzen Schnauzen und den galanten Armen und Beinen. Ich kann mich aber auch in irgendeinen kleinen, ‚markenlosen' Teddy verlieben. Jeder Bär hat seine ganz eigene Ausstrahlung."

Allen Aufnahmen von Mirja sieht man dabei eines an: Sie spürt die Seele der Teddys auf. Sie läßt sich bei allen ihren Inszenierungen immer vom individuellen Ausdruck eines Bären inspirieren. Mit humorvoller Phantasie porträtiert sie ihre kleinen Modelle: mal mit schelmischem Blick, mal mit aristokratischer Würde, beim Segeln, beim Bergsteigen oder gar als Ritter. Ihre Fotos sind das Ergebnis einer Leidenschaft, die Mirja de Vries mit vielen teilt. Sie bringt es ganz einfach zum Ausdruck: „Teddybären fotografieren macht Spaß" – und das sieht man.

# OURS EN PELUCHE

Encore tout pelucheux ou limé jusqu'à la corde, brun, beige ou noir, depuis 90 ans que dure son histoire, le nounours a fait la conquête de millions de cœurs. Pour beaucoup, il est resté le compagnon fidèle de toute une vie. La célèbre photographe Mirja de Vries en a fait son sujet de prédilection. Des ours en peluche, oui, mais pas n'importe lesquels : seuls les bons vieux nounours usés et uniques, qui portent encore les traces de notre affection et de nos états d'âme l'intéressent. Borgnes, tordus, ou sans oreilles, qu'importe ! Ils expriment la vie, voilà tout. A sa manière, Mirja de Vries réussit à faire parler les compagnons de notre enfance.

Durant ses études de graphisme et de photographie, elle a déjà réalisé un album sur le thème d'un canard mort... Dès 1975, elle fait paraître son premier livre sur les peluches, Knuffels. Depuis les années 80, elle ne se consacre plus qu'à nos nounours aimés et parfois malmenés, que tout le monde a déjà vus sur des cartes postales, des posters ou des calendriers. « Photo-

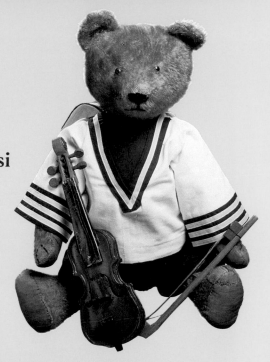

graphier des ours en peluche n'est pas si simple. Il faut avoir une relation particulière envers eux, sinon ça ne marche pas. J'aime surtout les vieux ours de Steiff. Ils ont un charme bien à eux. Mais je peux aussi bien tomber amoureuse de n'importe quel petit ours sans marque ›. »

Ses clichés pleins de sensibilité dénotent son aptitude à dévoiler l'âme de ses modèles et de leurs propriétaires... Avec humour et imagination, elle crée des mises en scène uniques, en fonction de leurs expressions : effrontés ou d'une dignité aristocratique, en train de faire de la voile ou d'escalader une montagne, ou tel le chevalier montant la garde ... Ses clichés sont à l'image de la passion dévorante qu'elle partage désormais avec beaucoup de petits et de grands enfants. Des photos qui expriment simplement, mais avec quelle verve, son plaisir de photographier des modèles qui ont tant à raconter ...

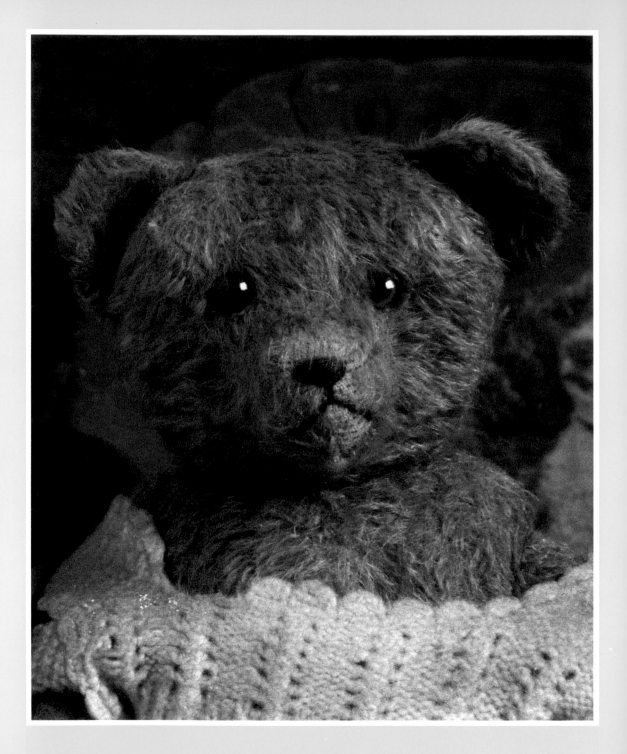

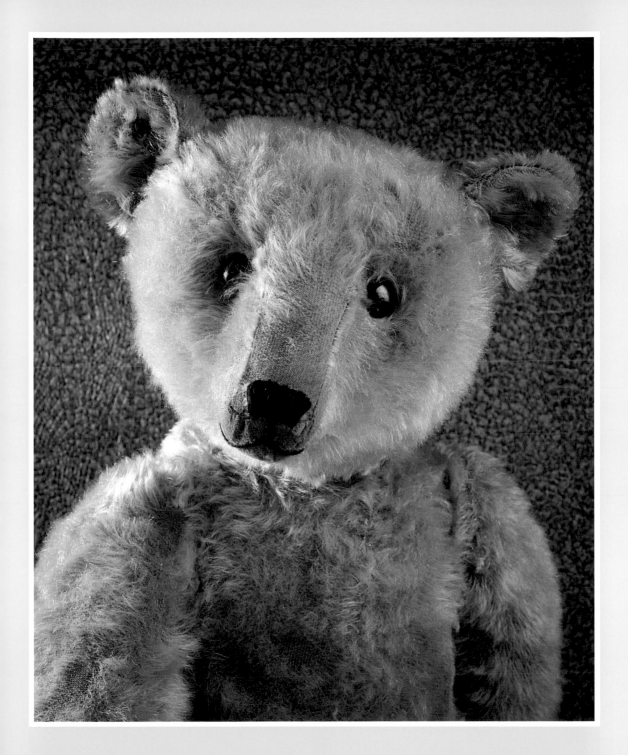

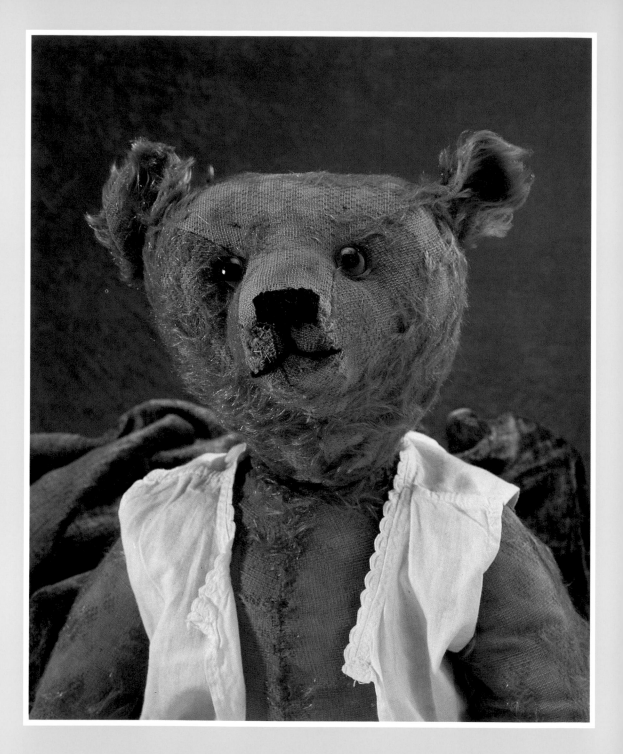

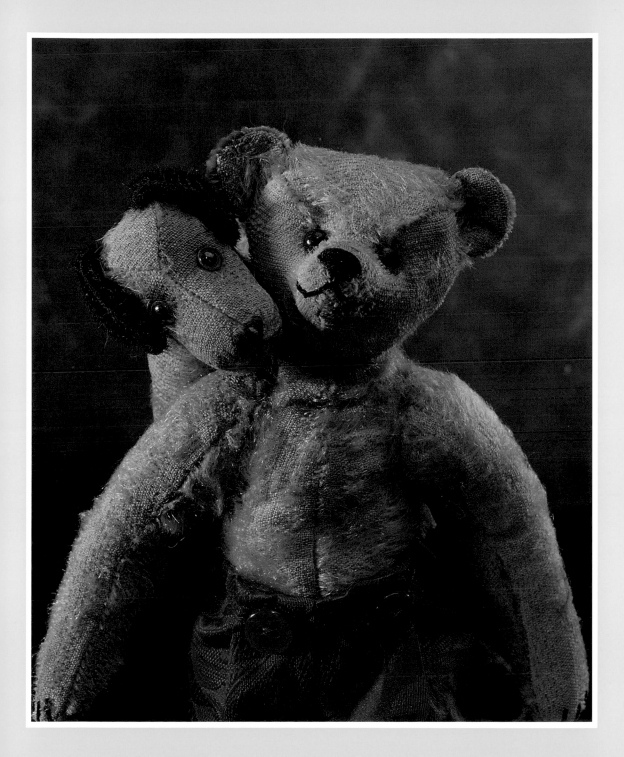

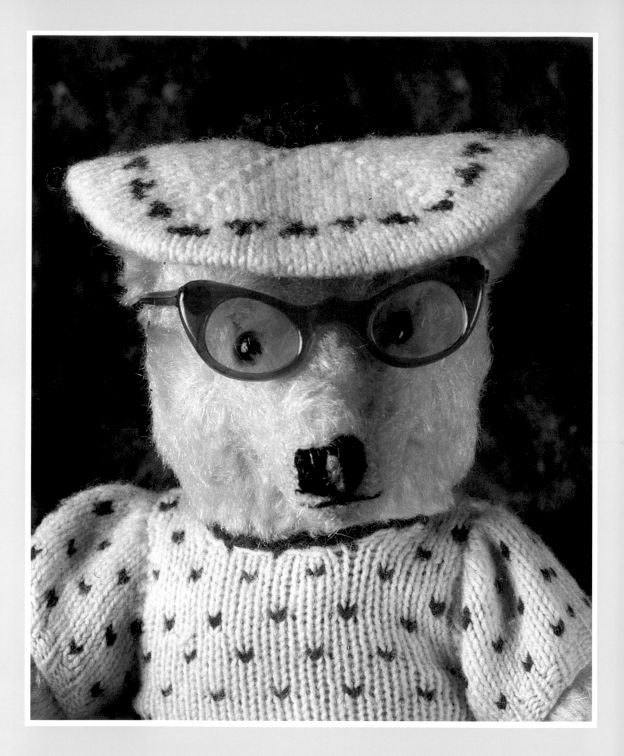

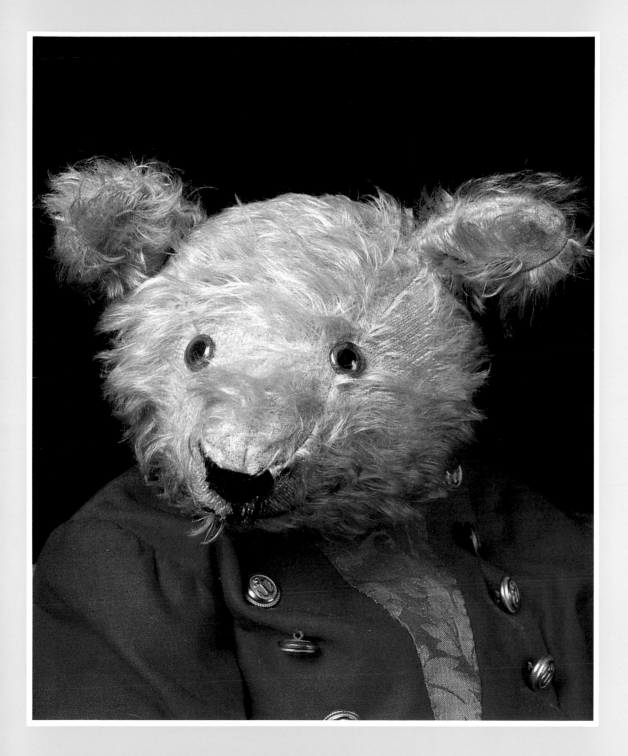

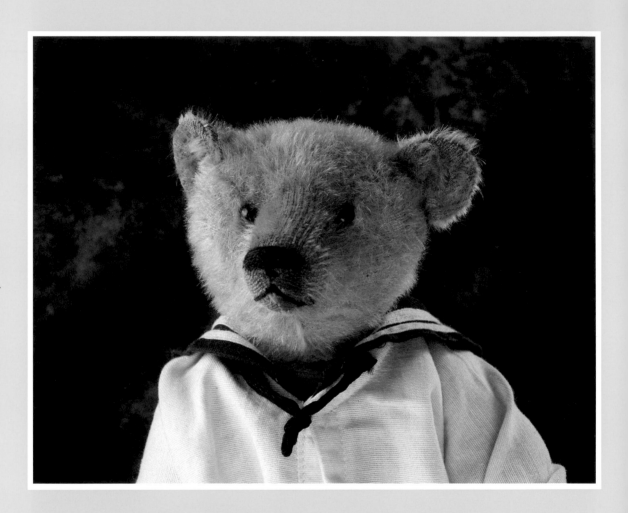

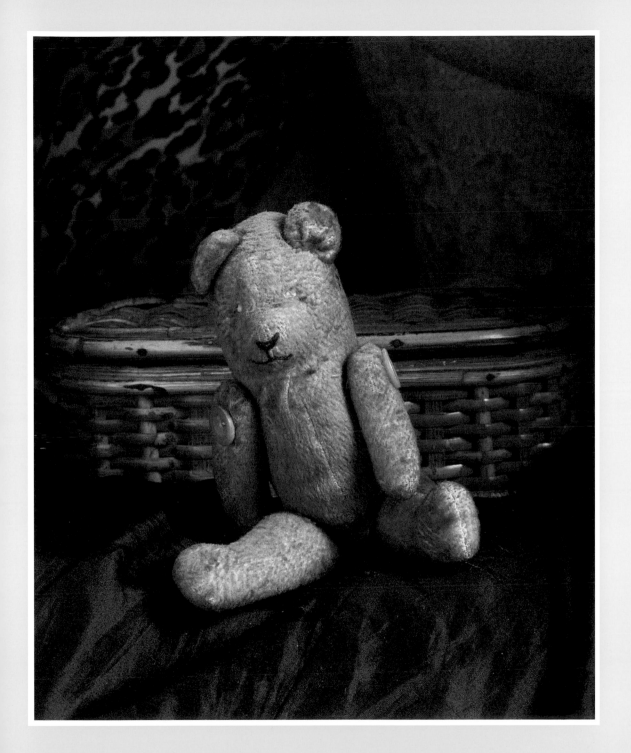

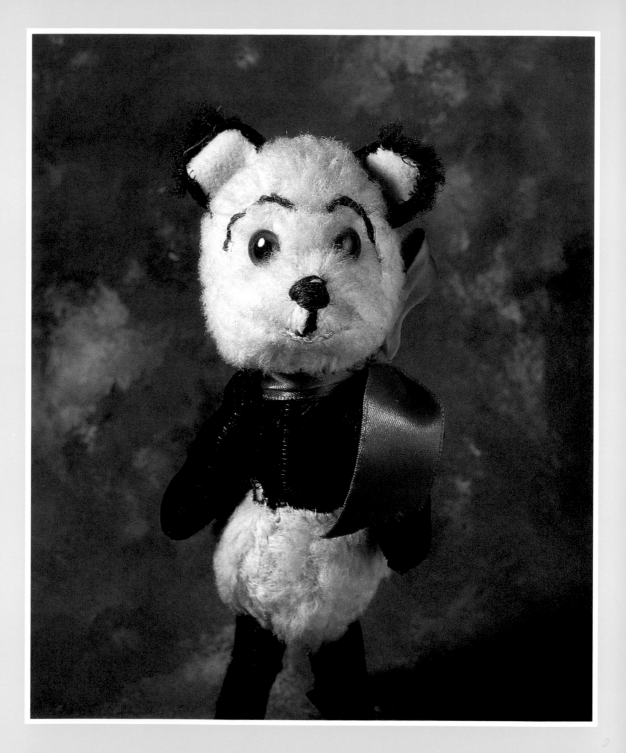

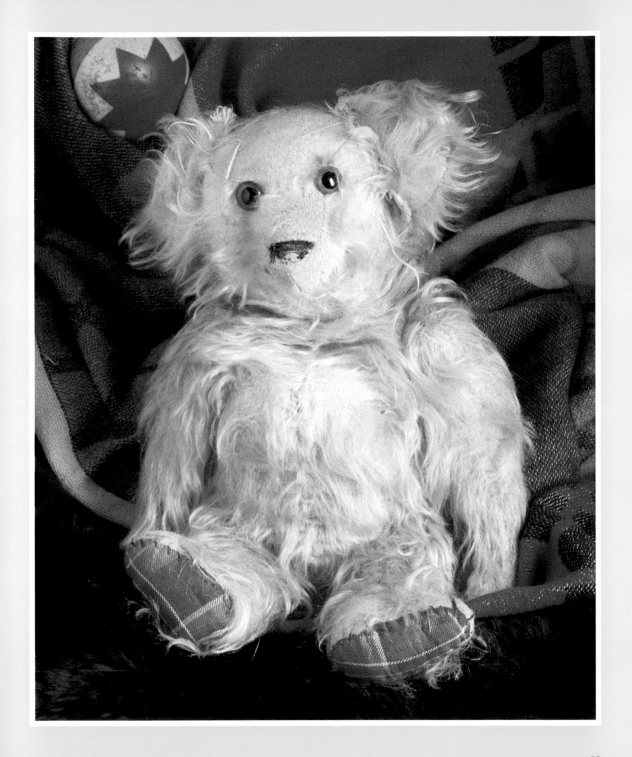

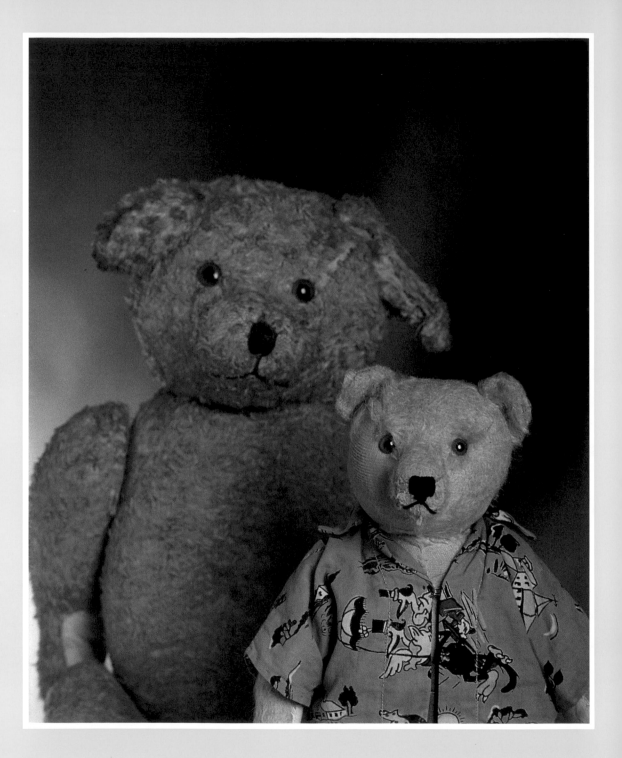

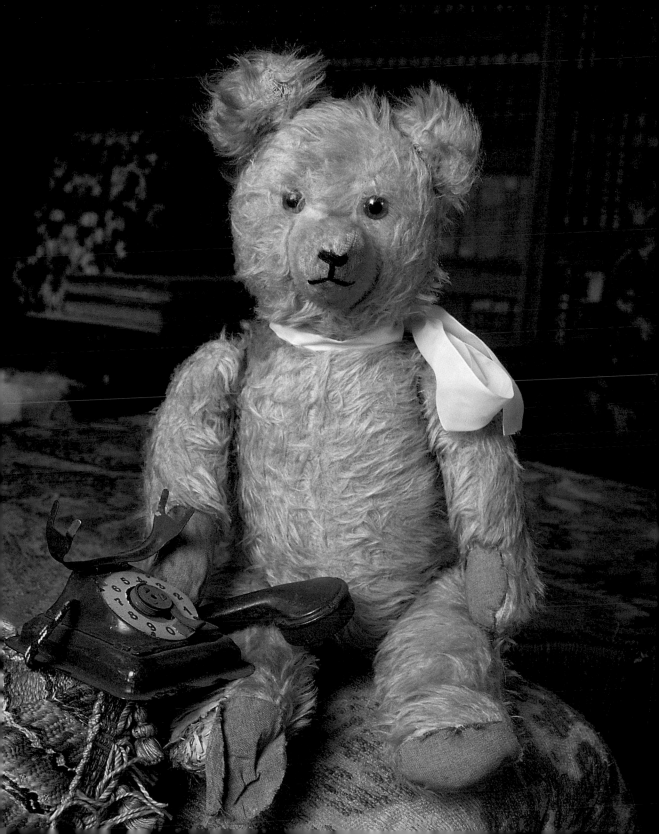

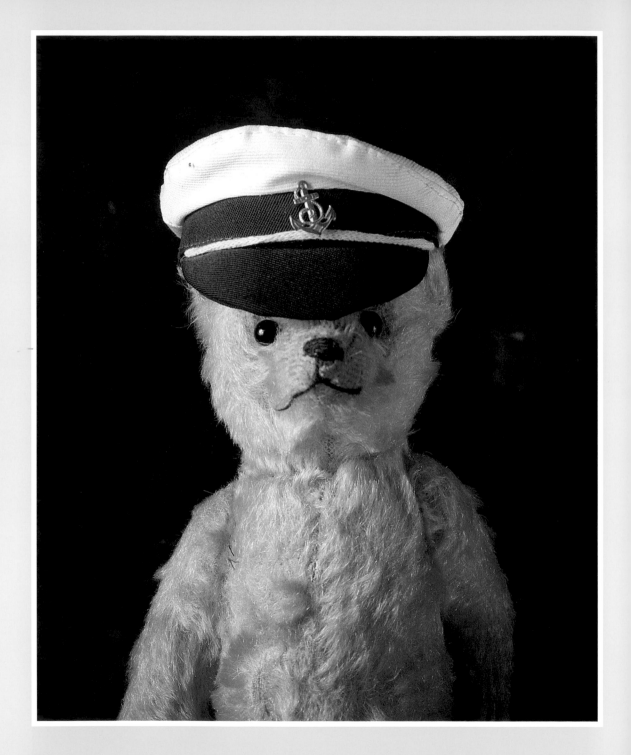

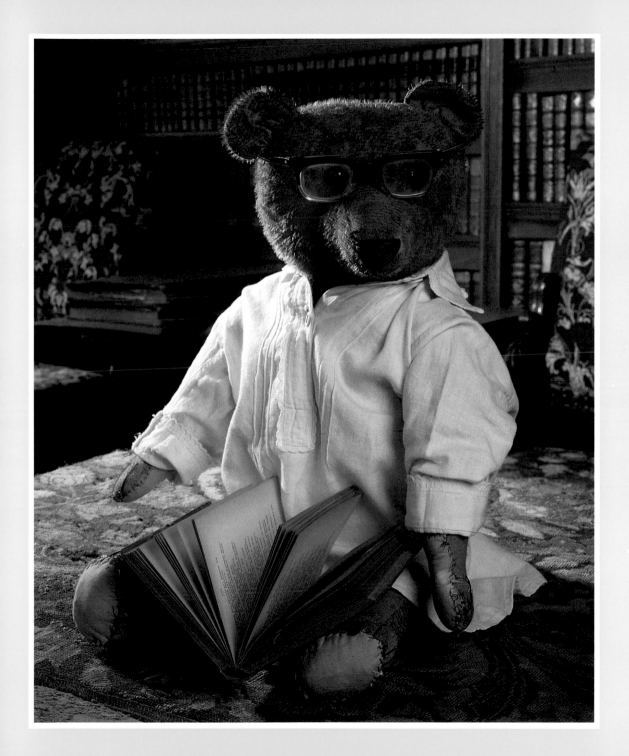

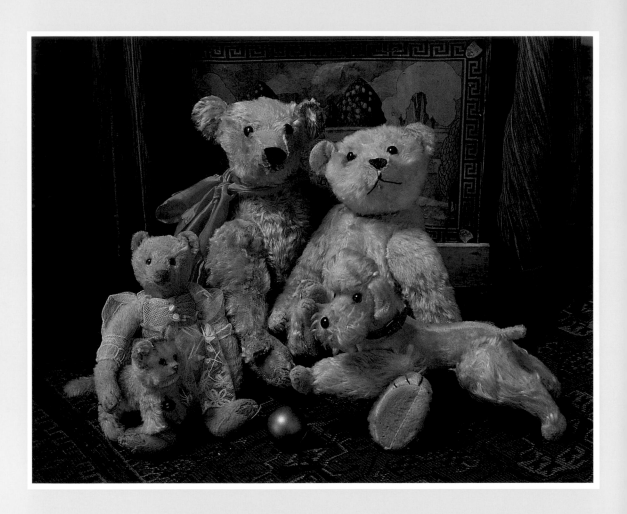

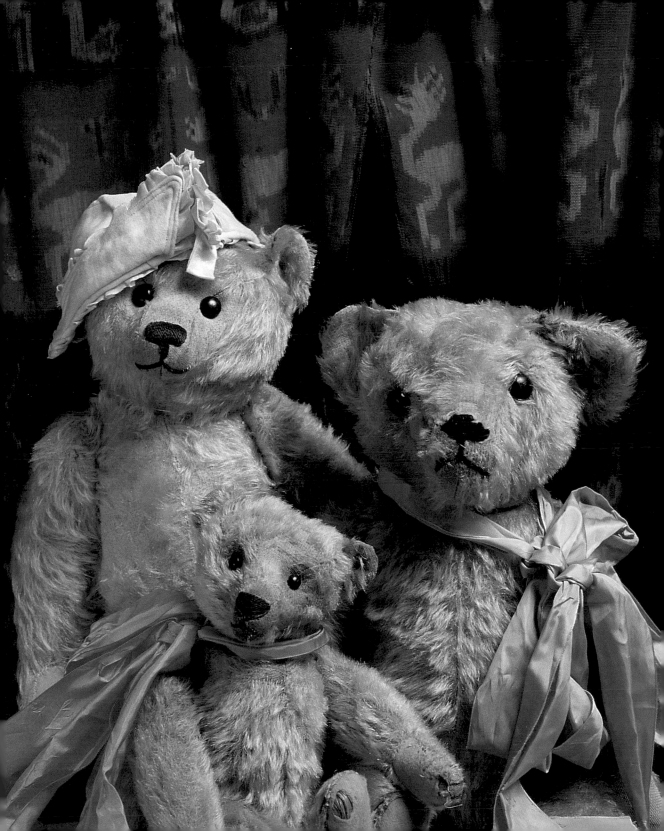

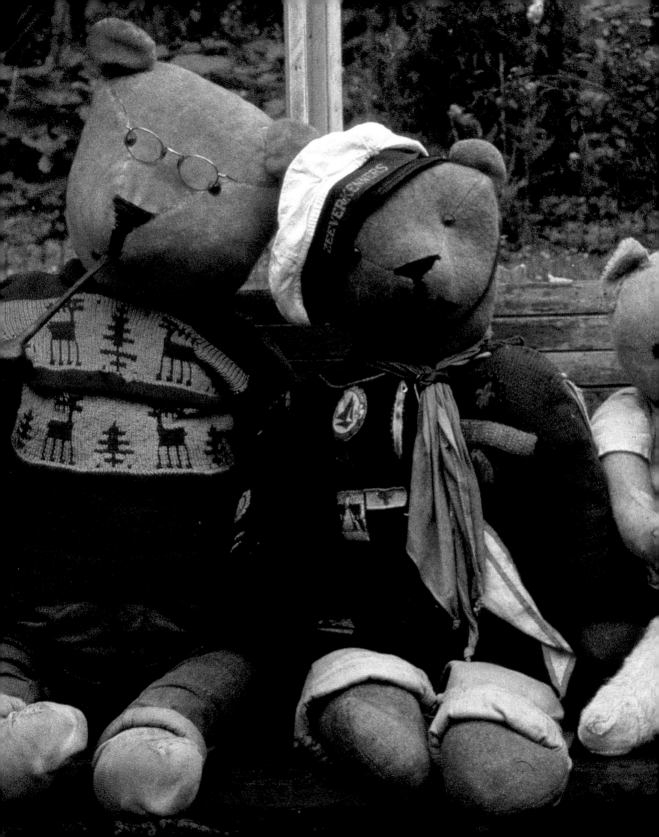

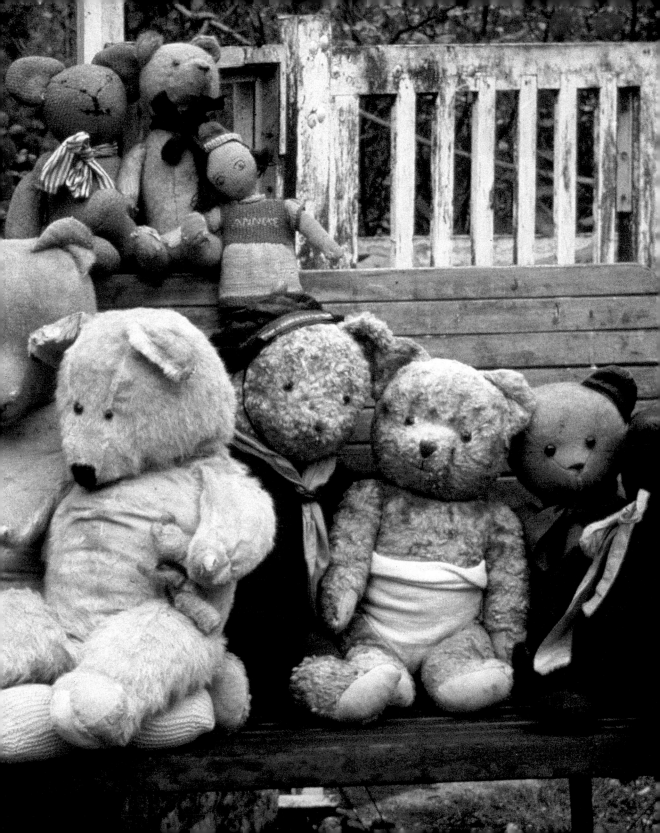

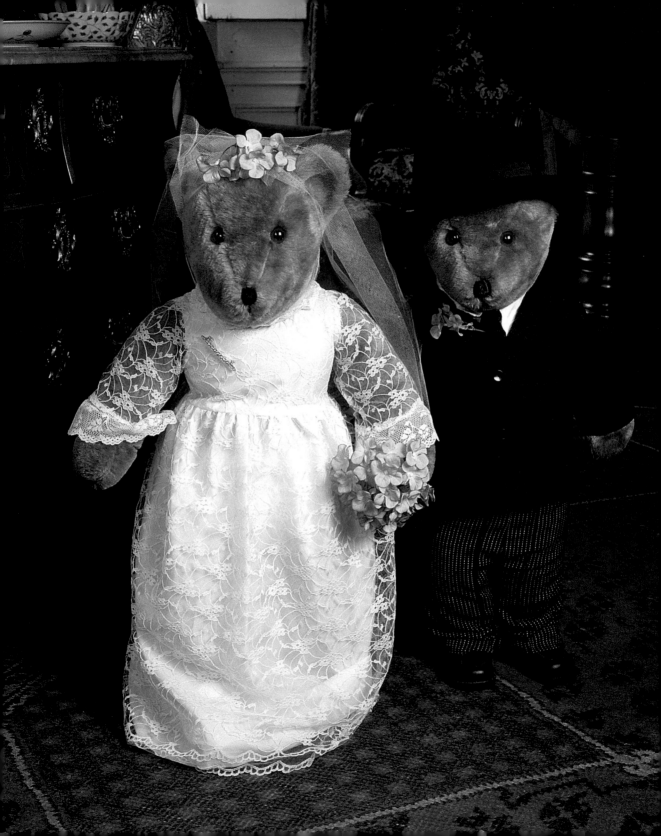

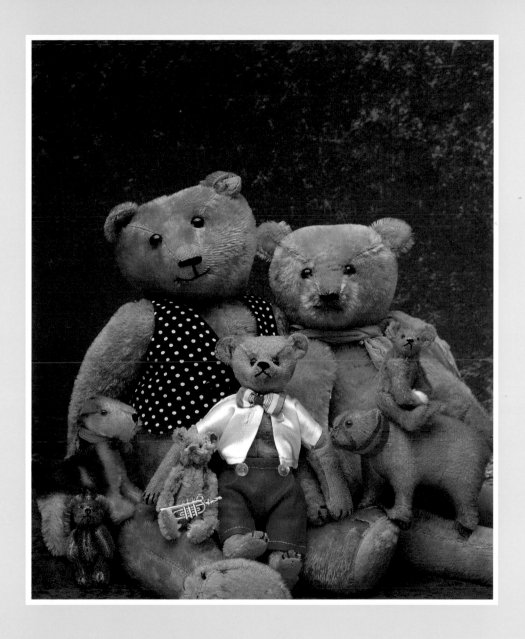

JUST MARRIED!

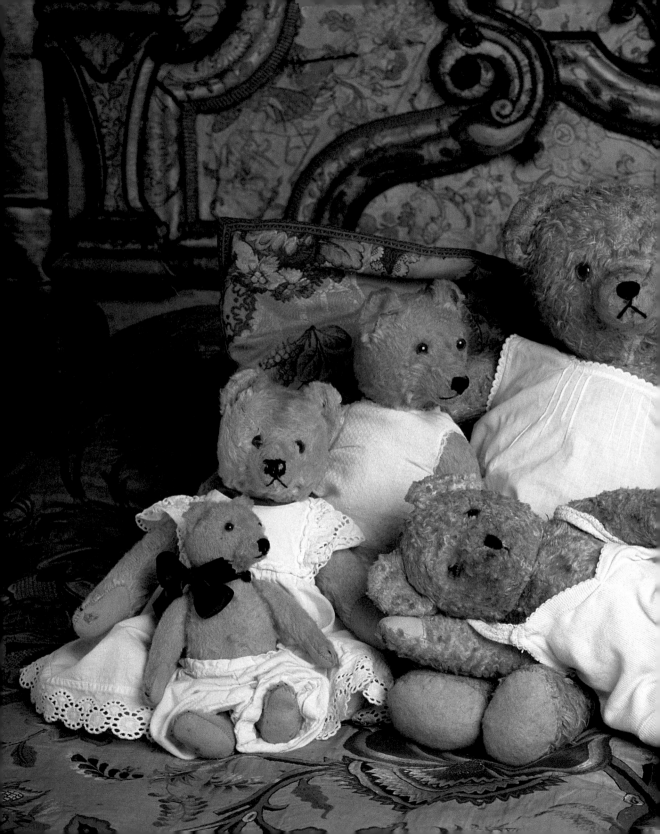

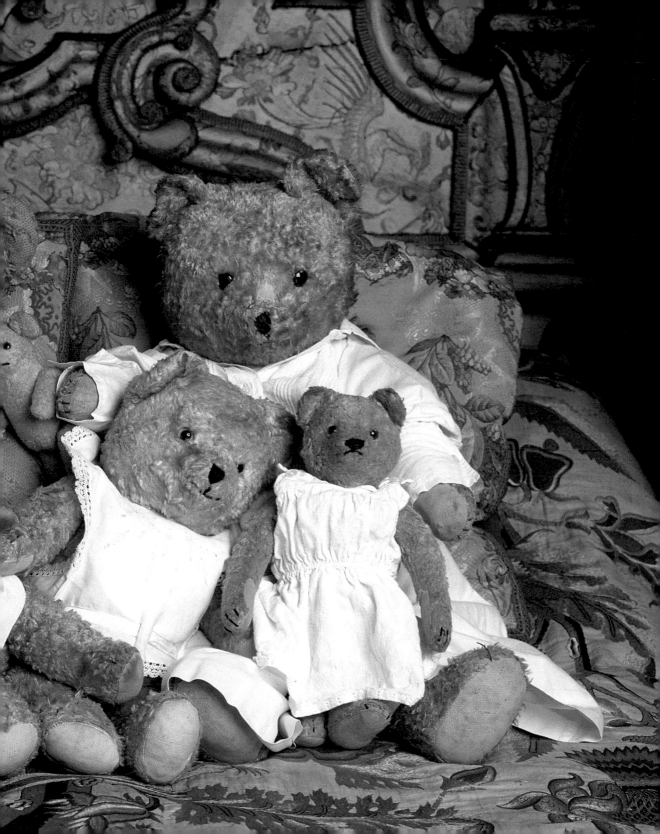

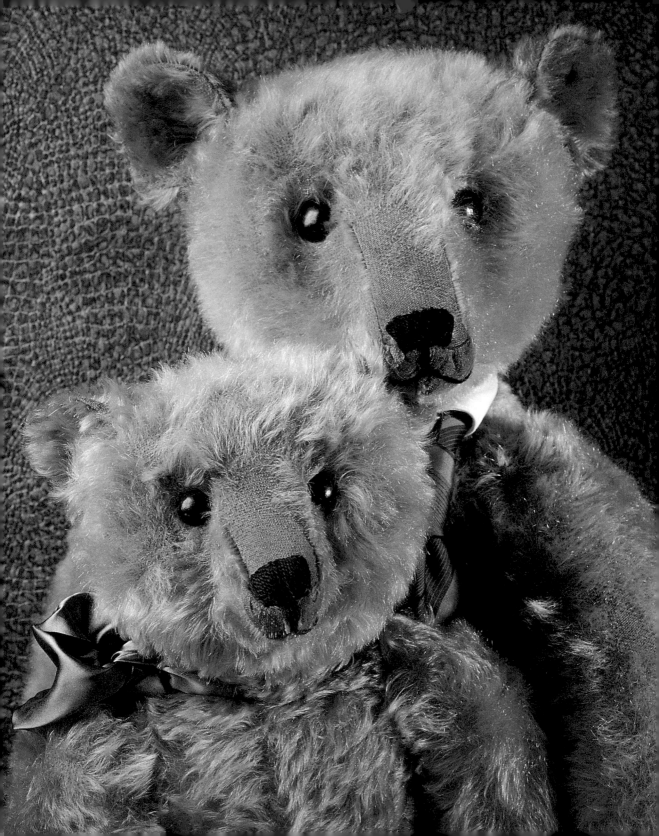

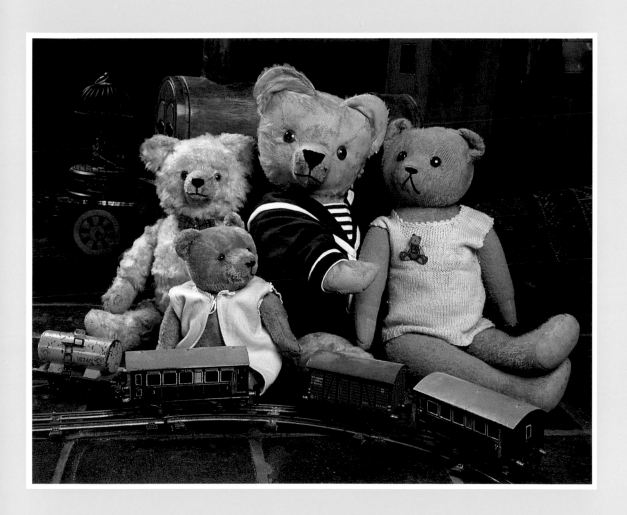

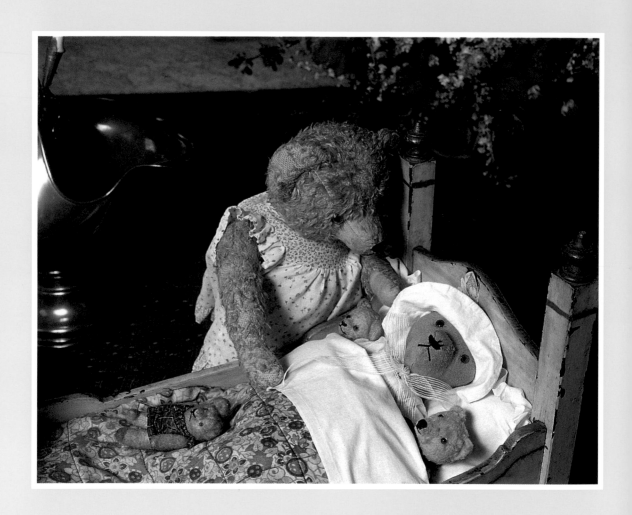

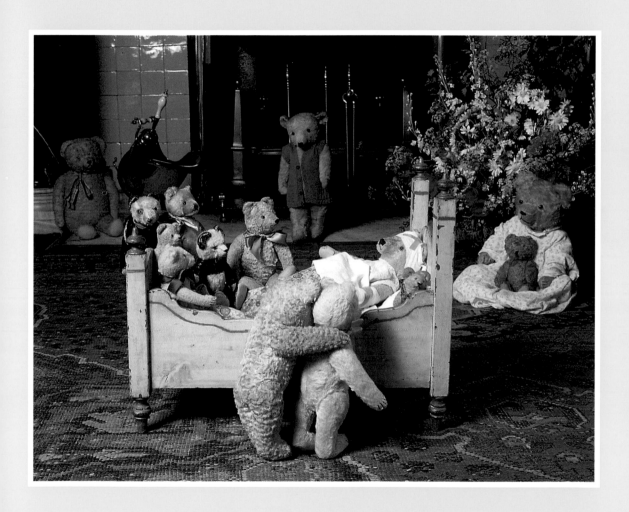

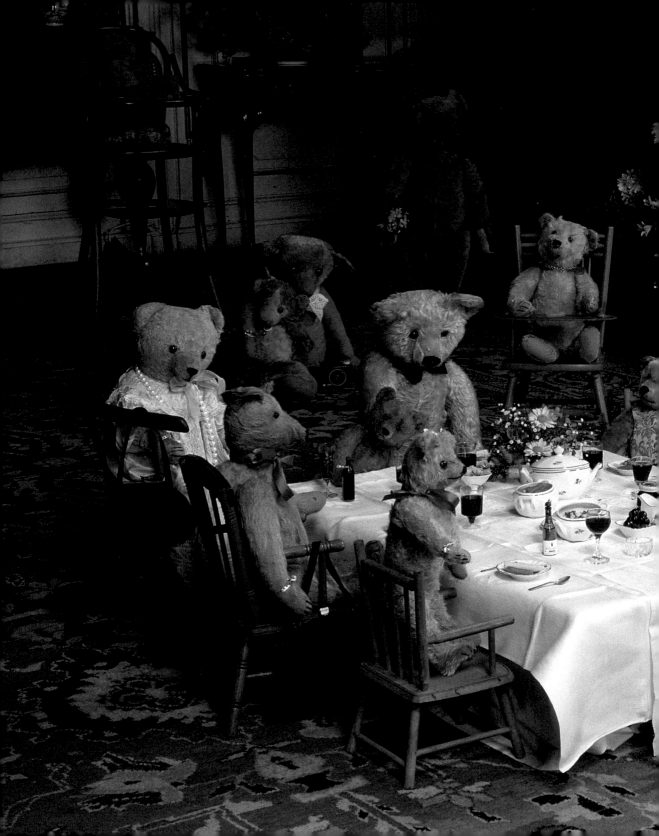

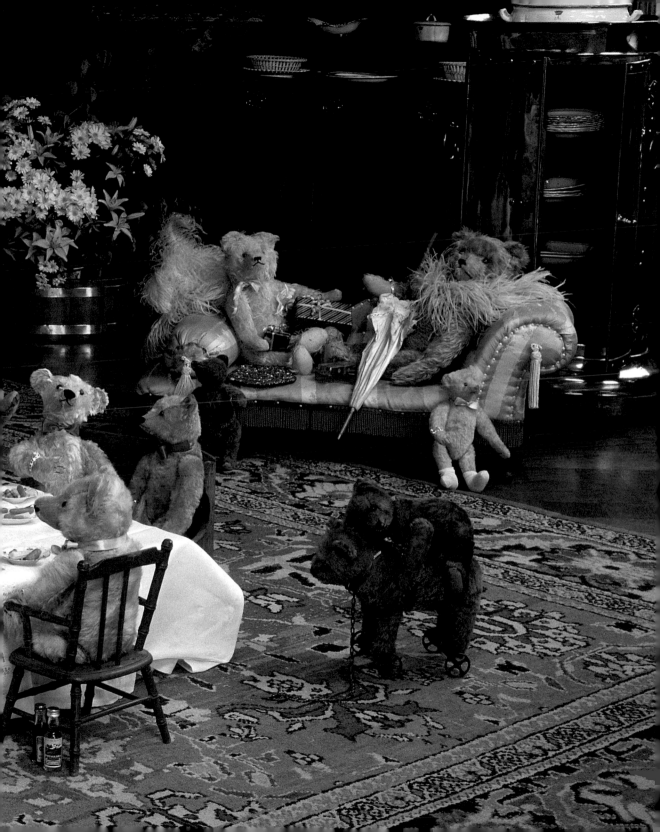

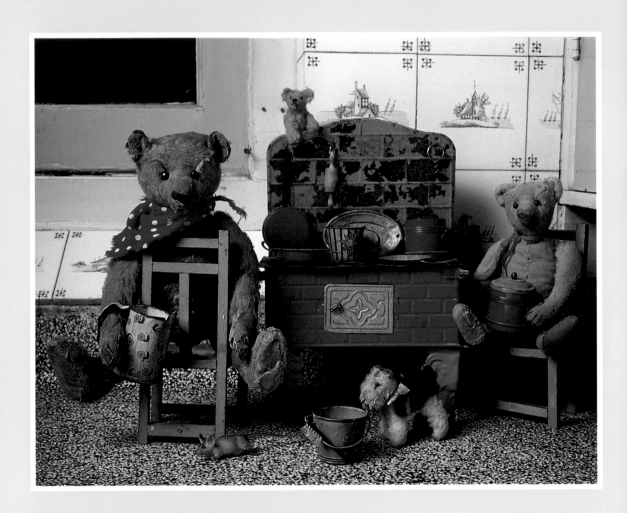

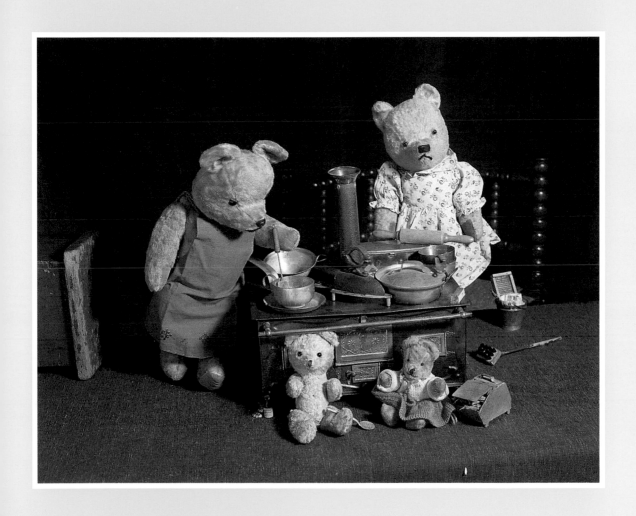

# DINNER FOR TEDDIES

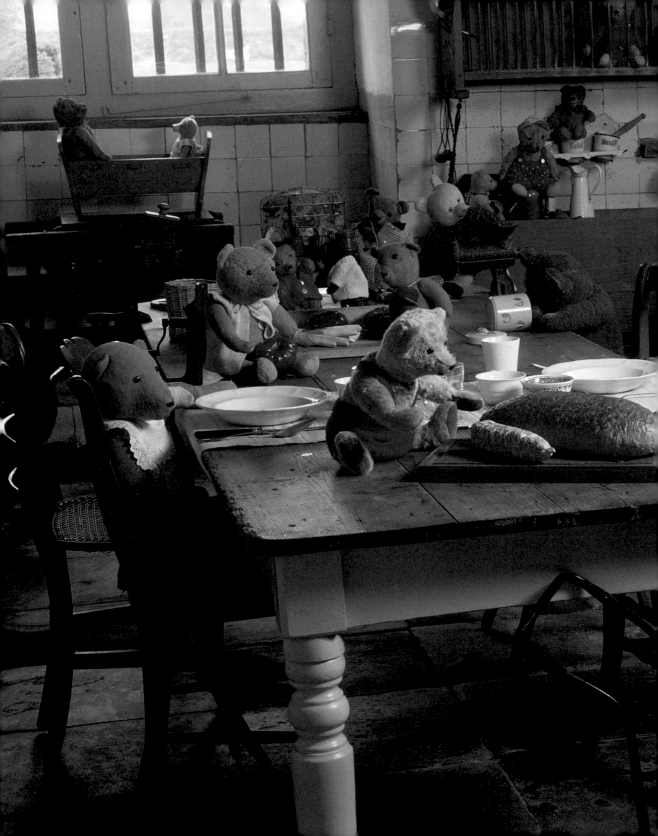

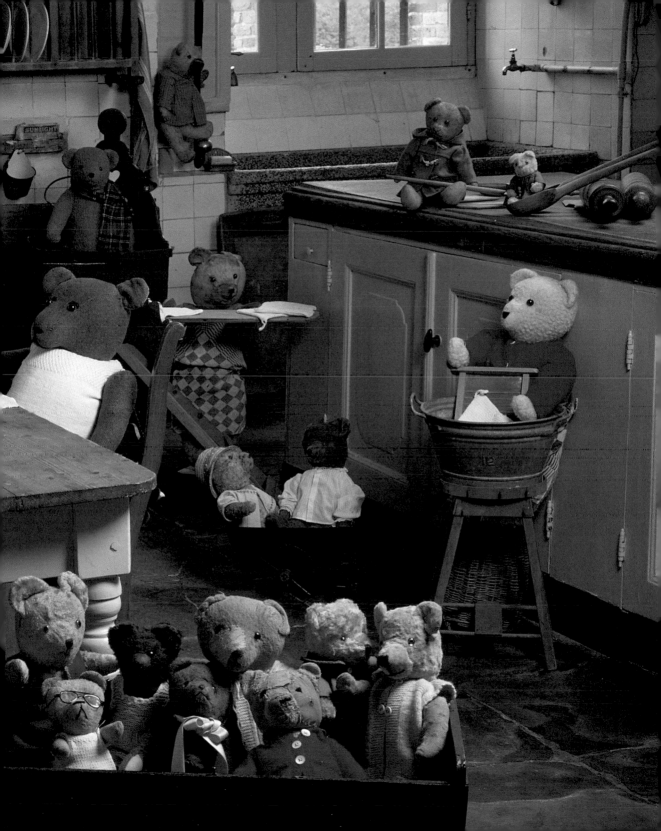

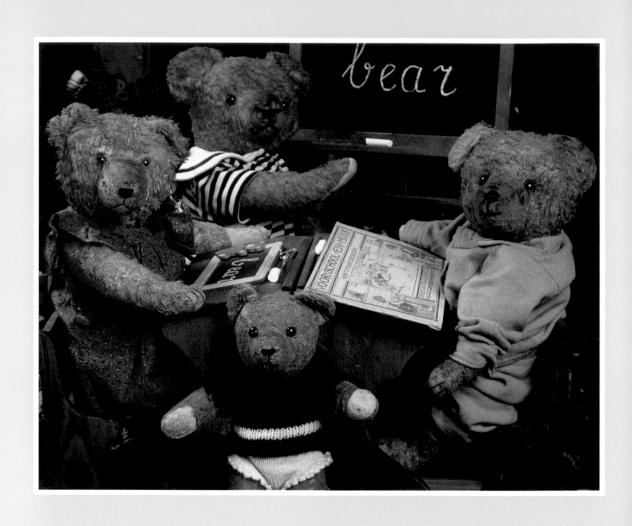

LEARNING bY

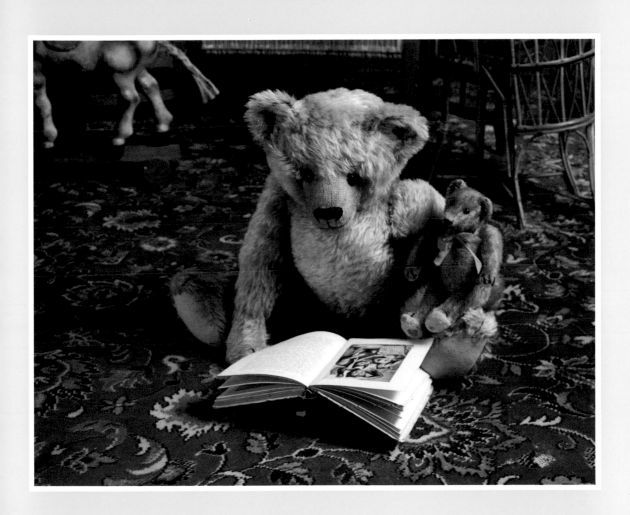

doing

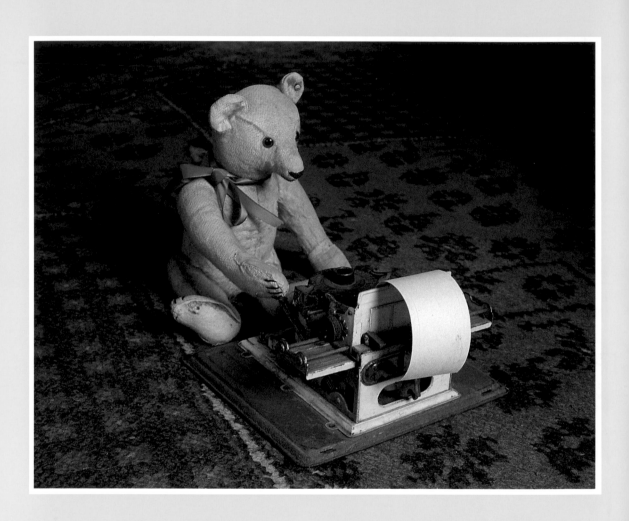

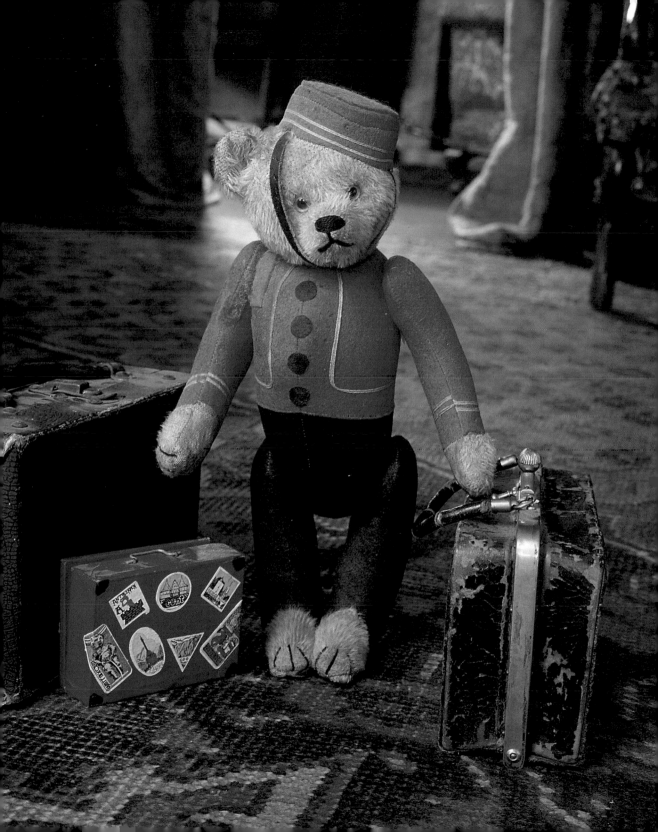

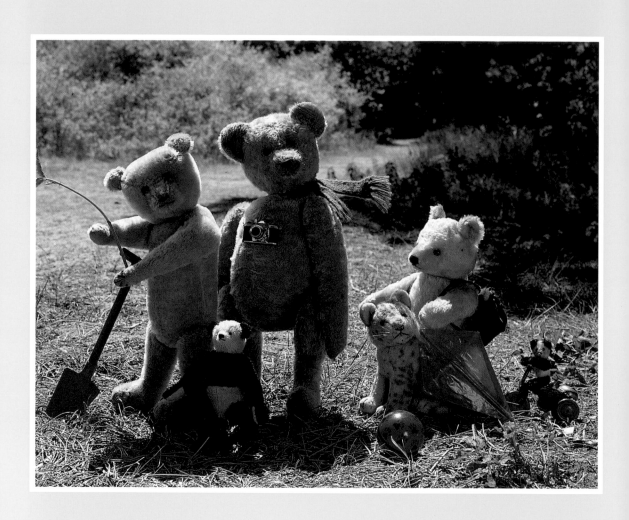

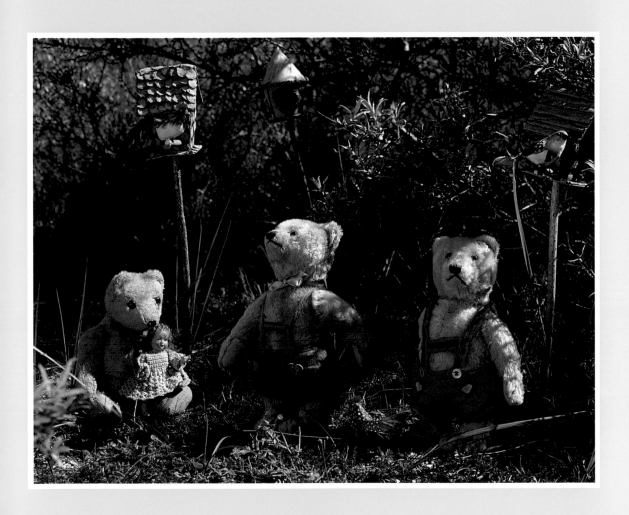

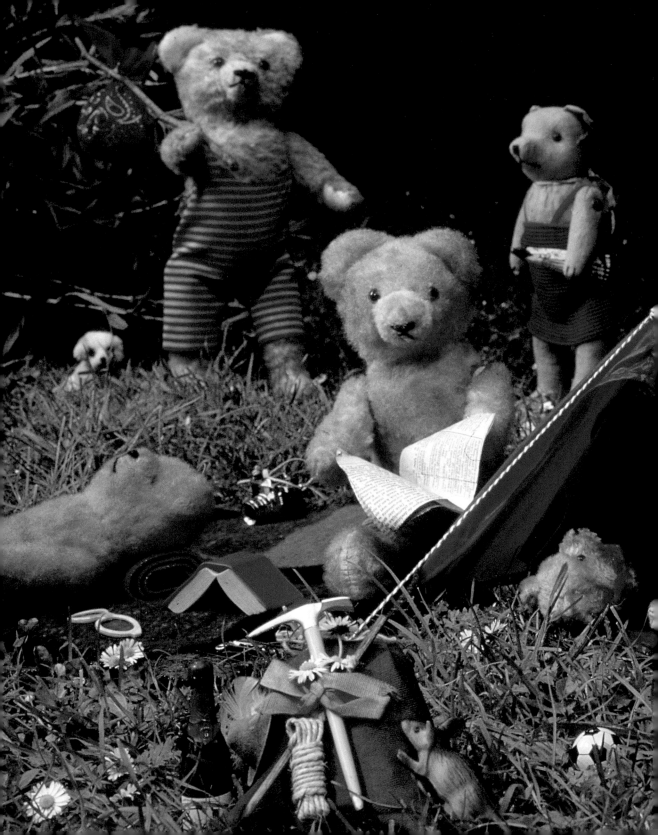

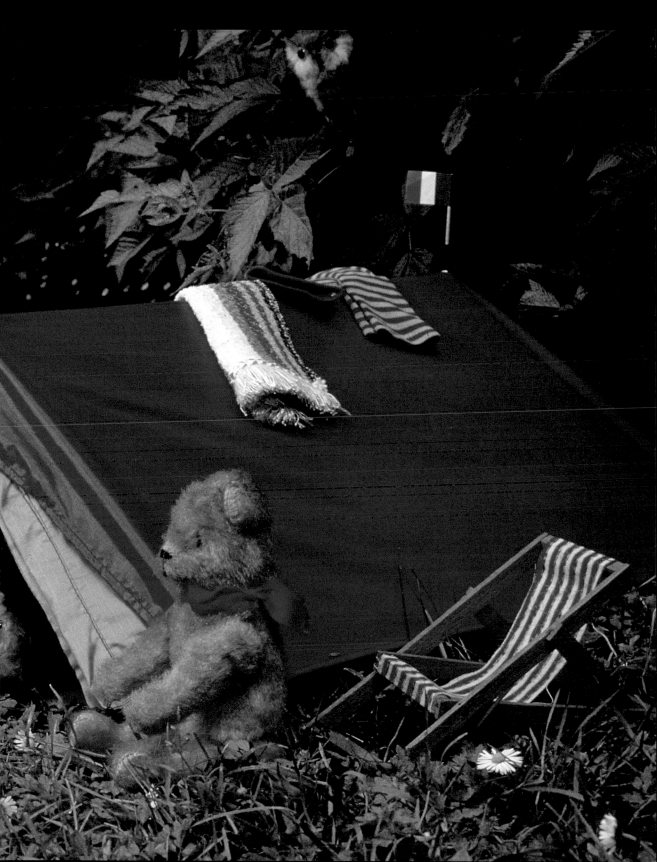

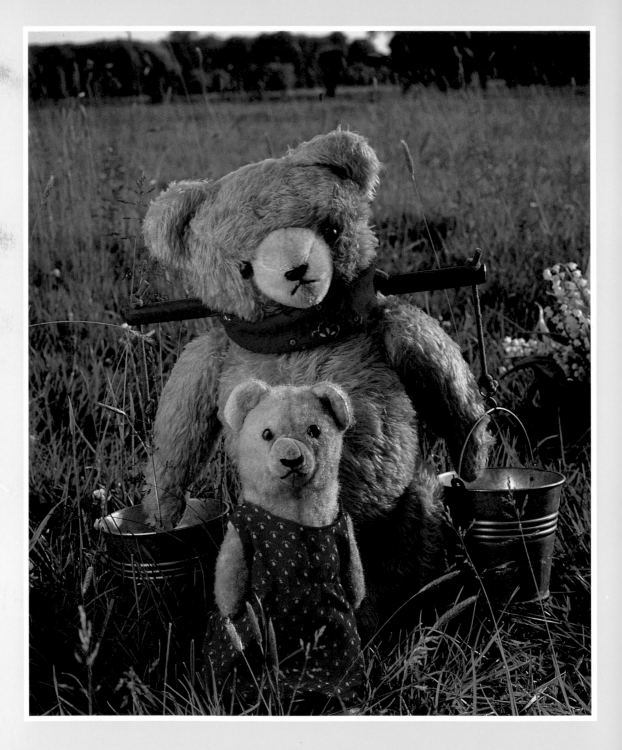

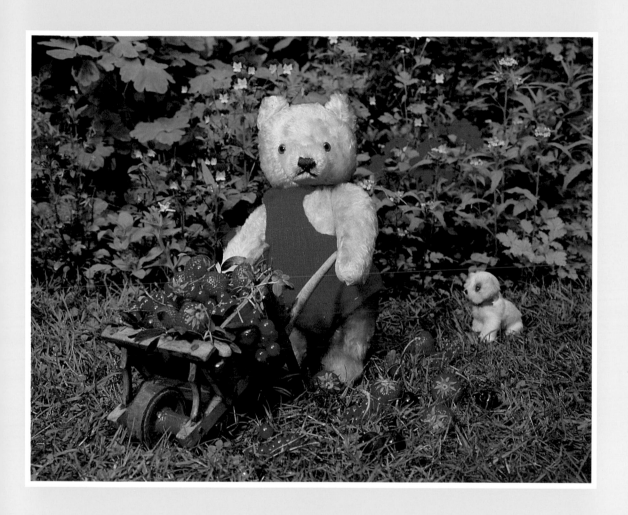

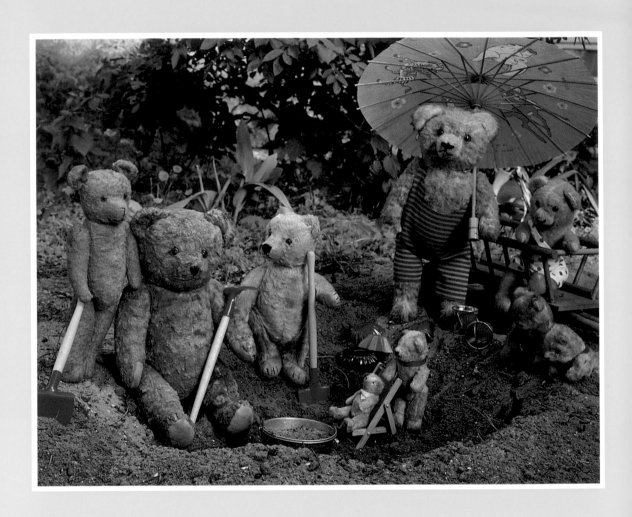

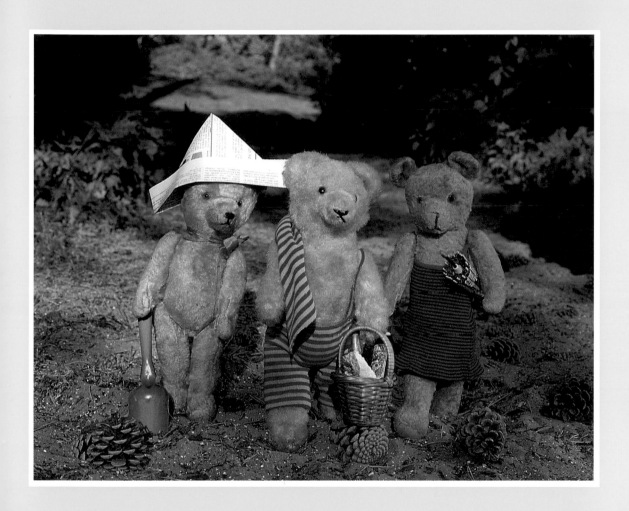

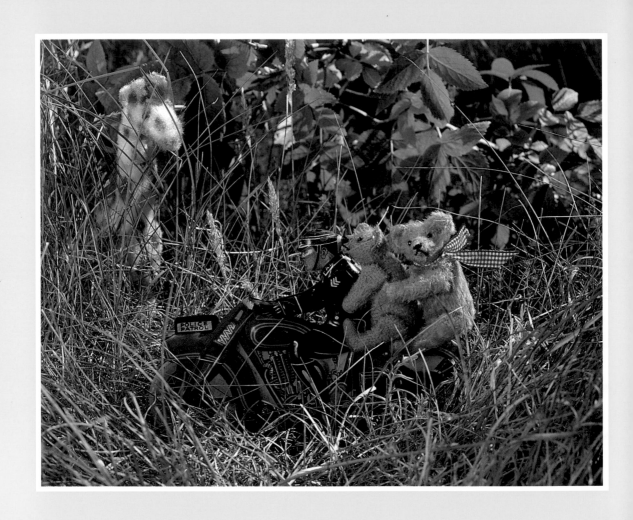

JUNGLE SAFARI

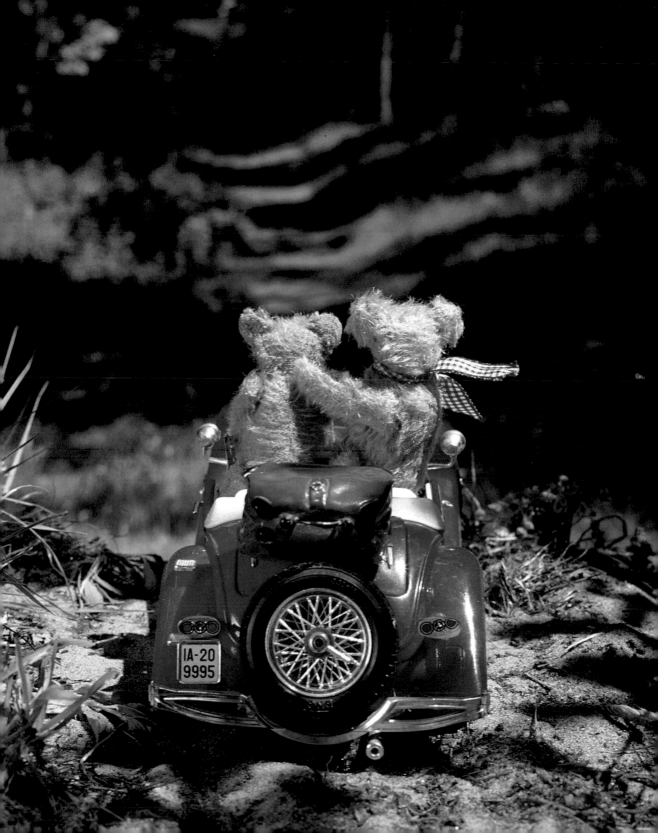

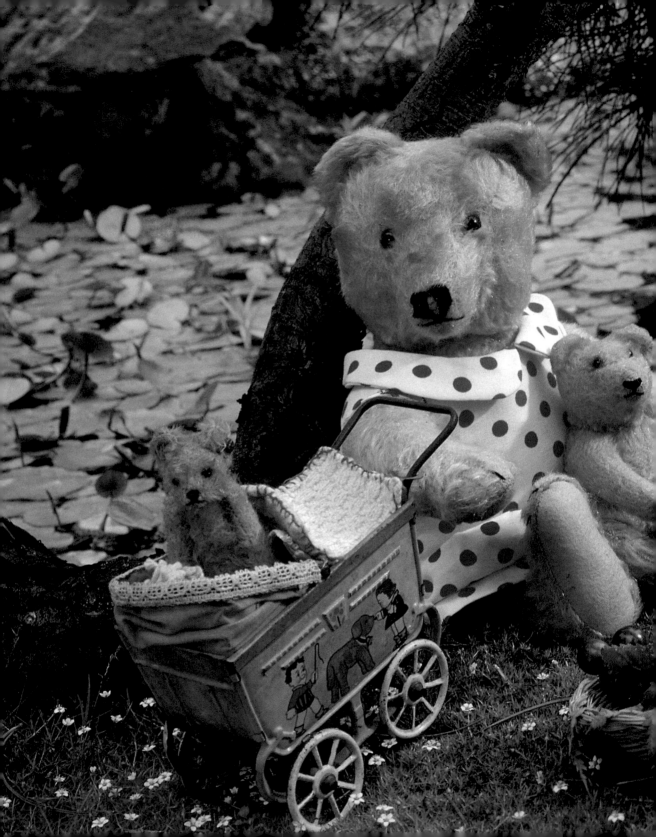

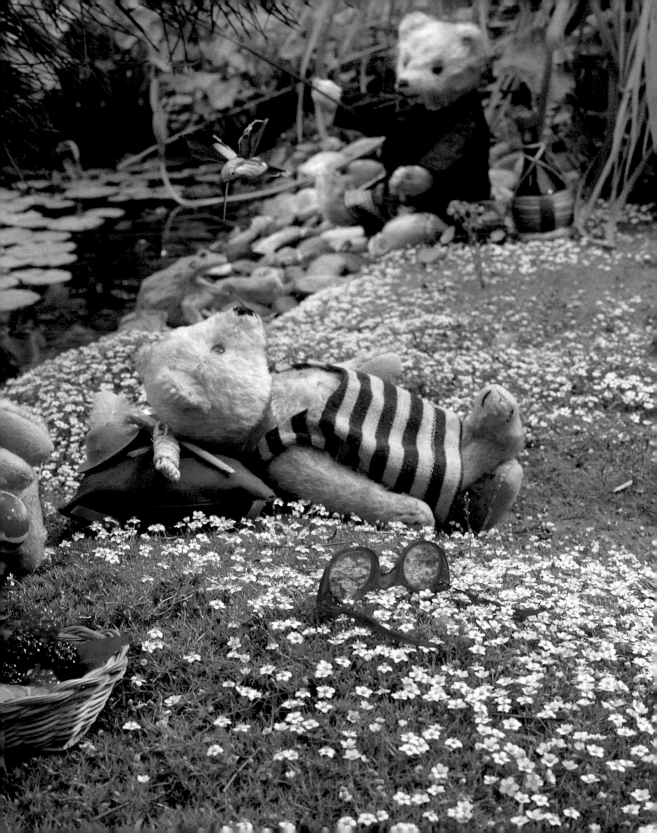

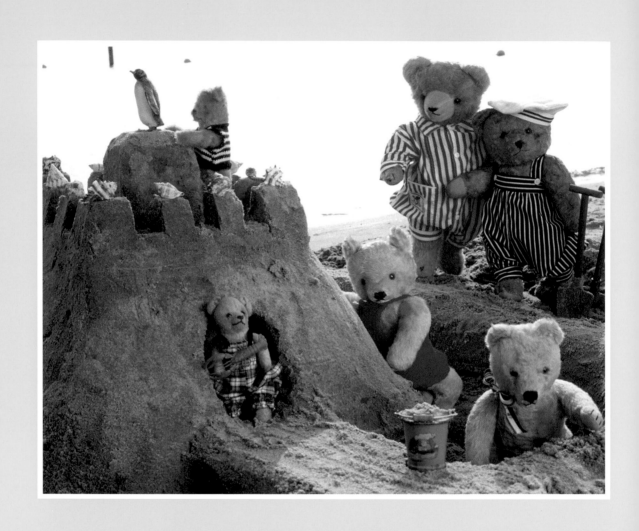

on the beach

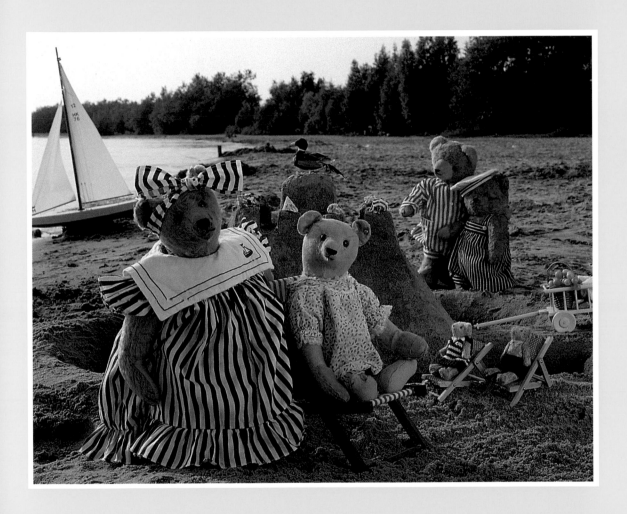

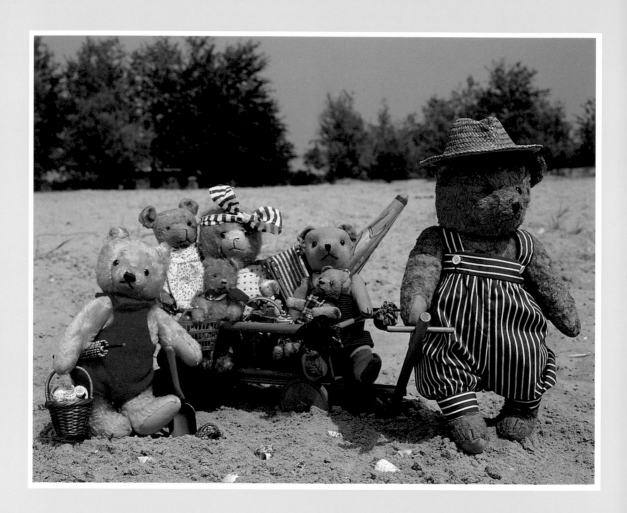

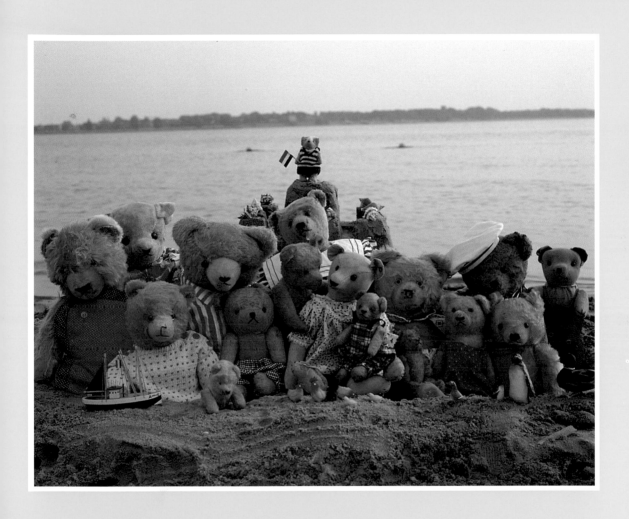

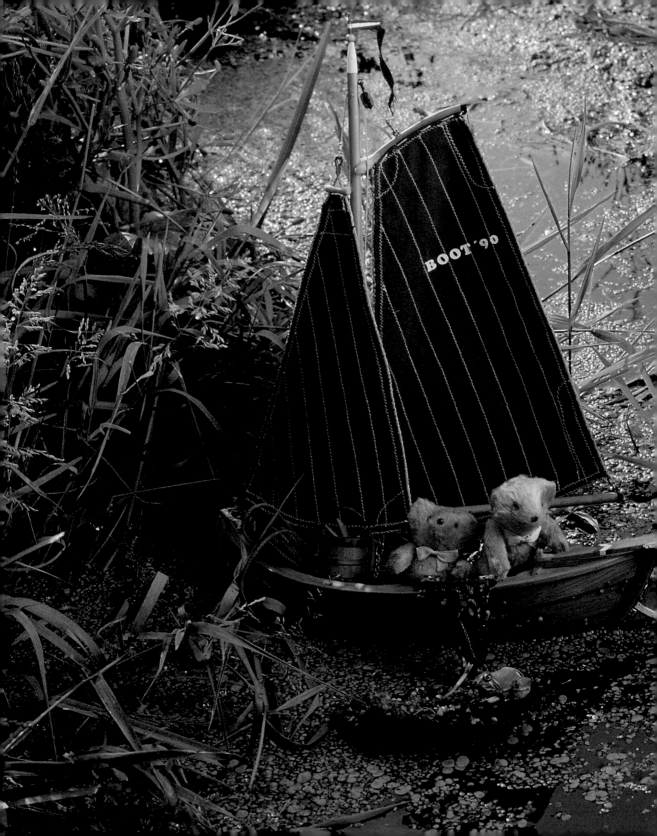

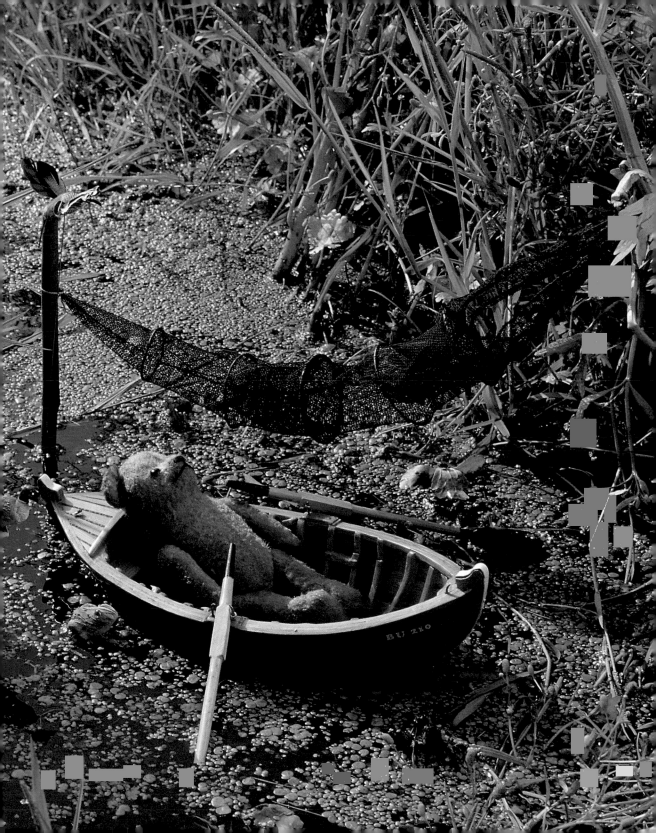

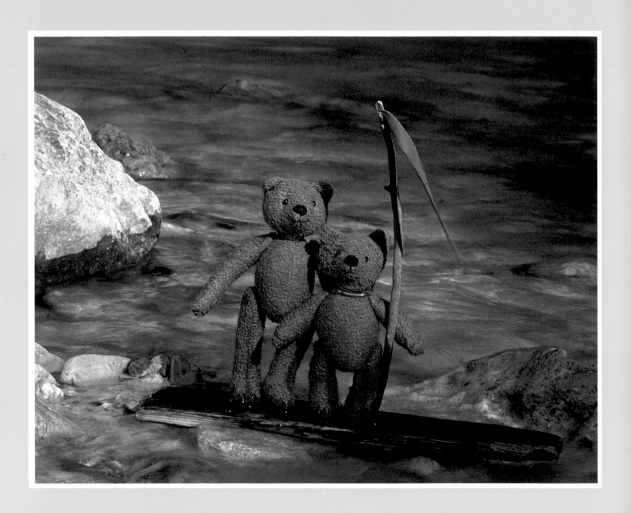

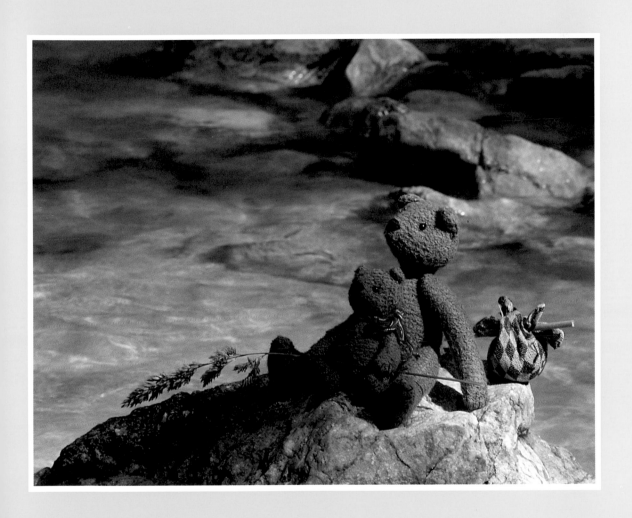

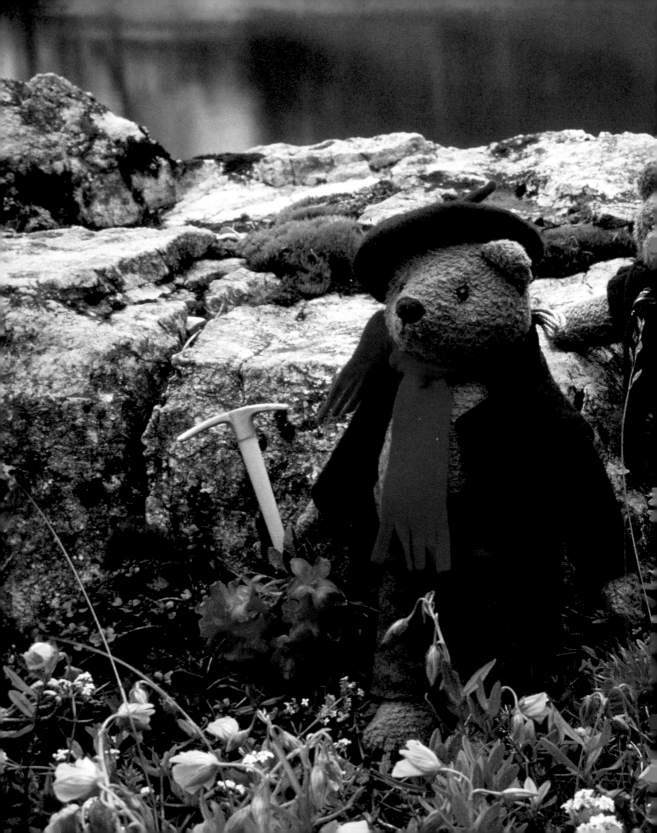

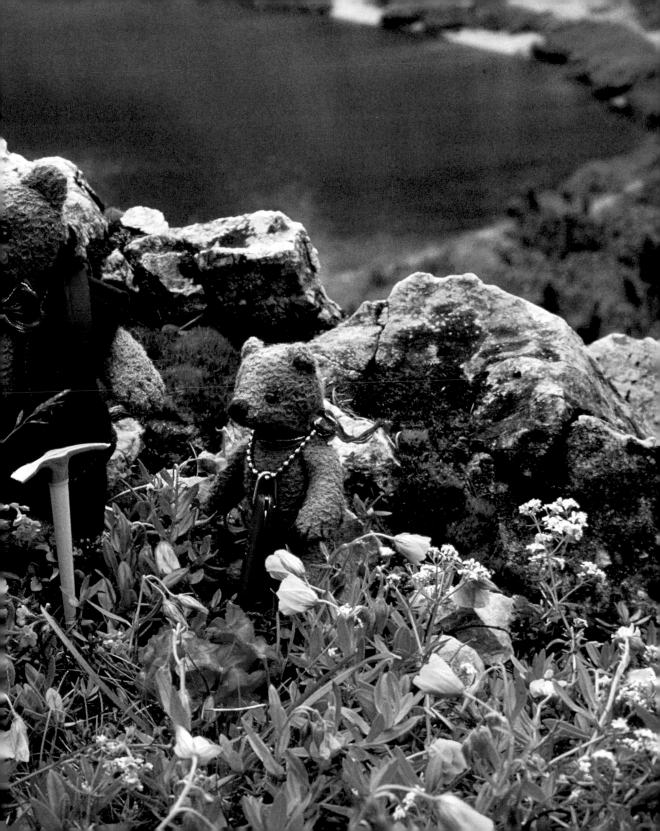

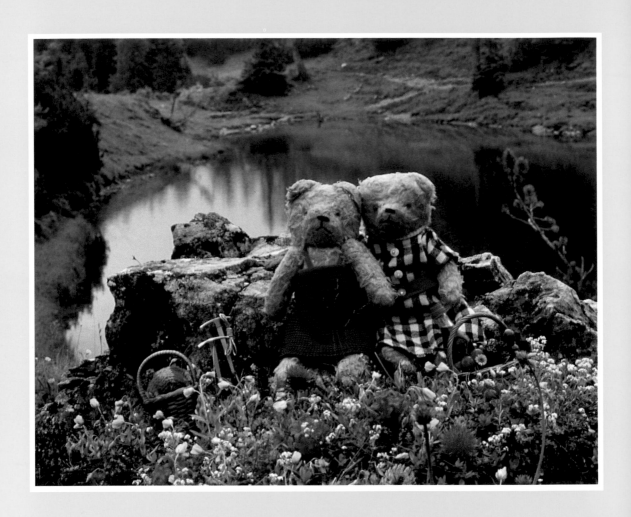

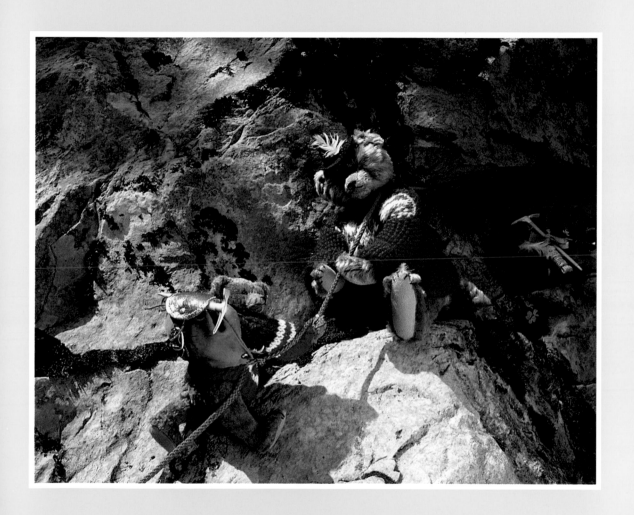

# FRee CLIMBing

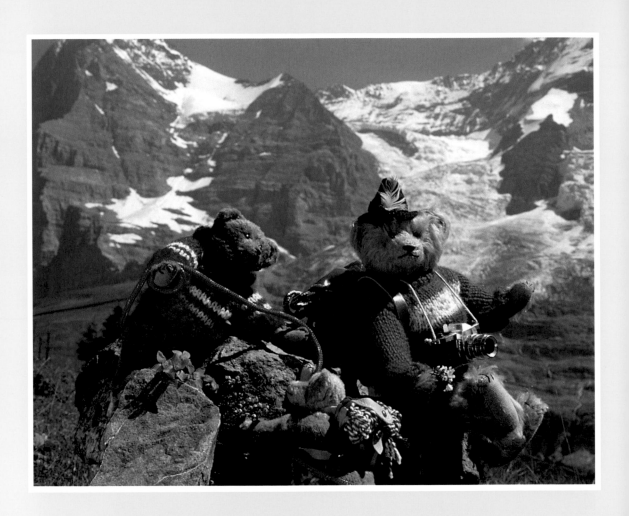

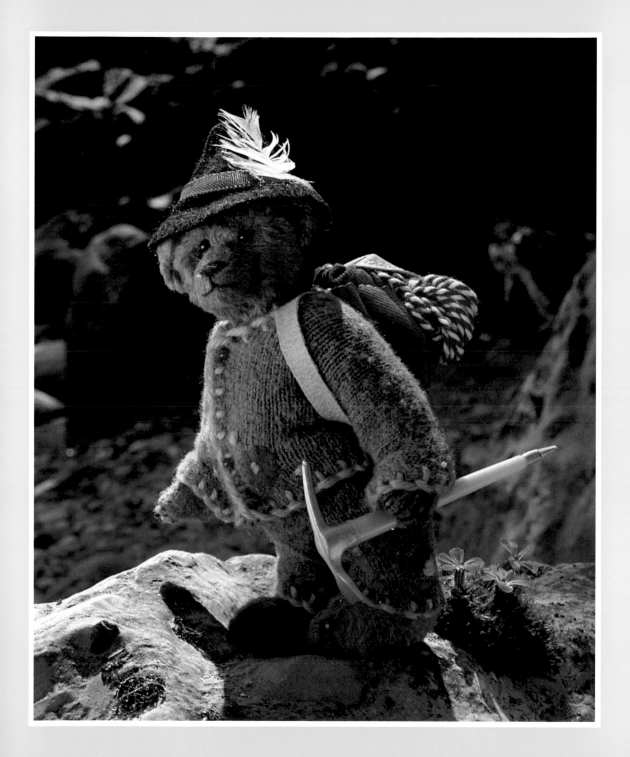

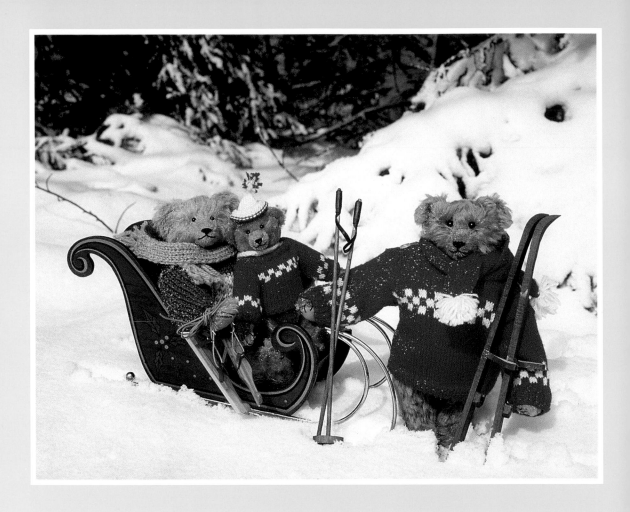

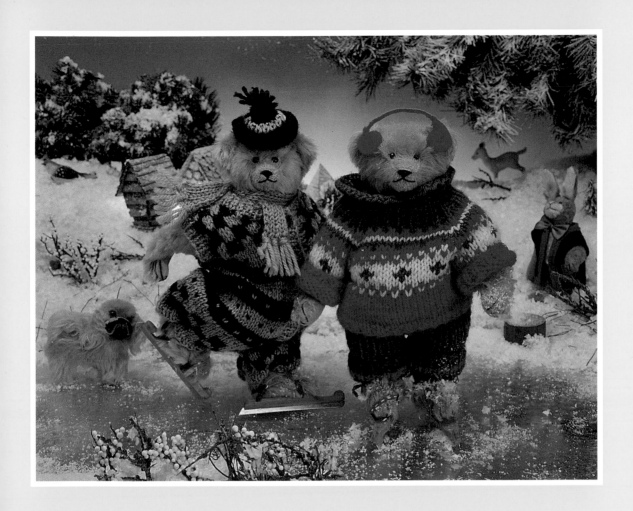

HOLIDAY ON ICE

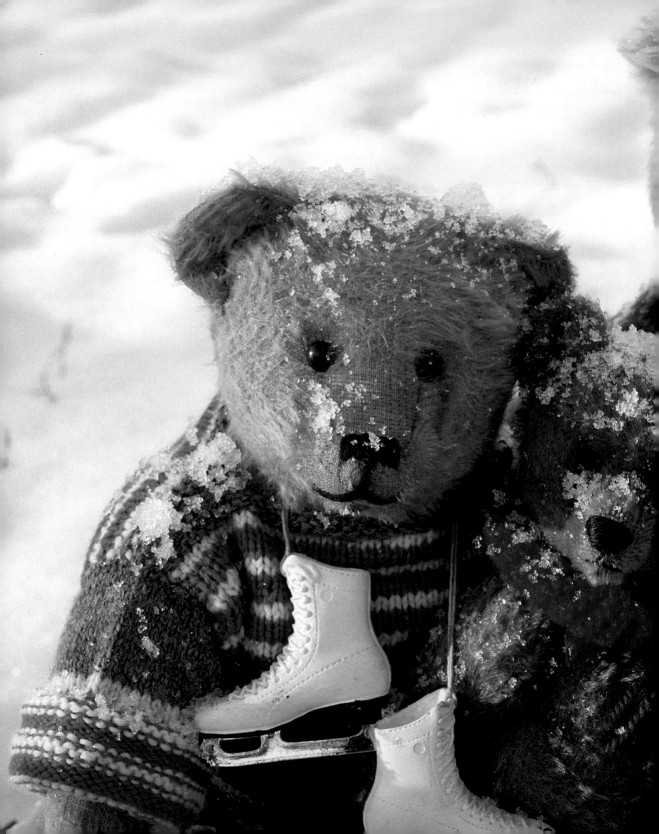

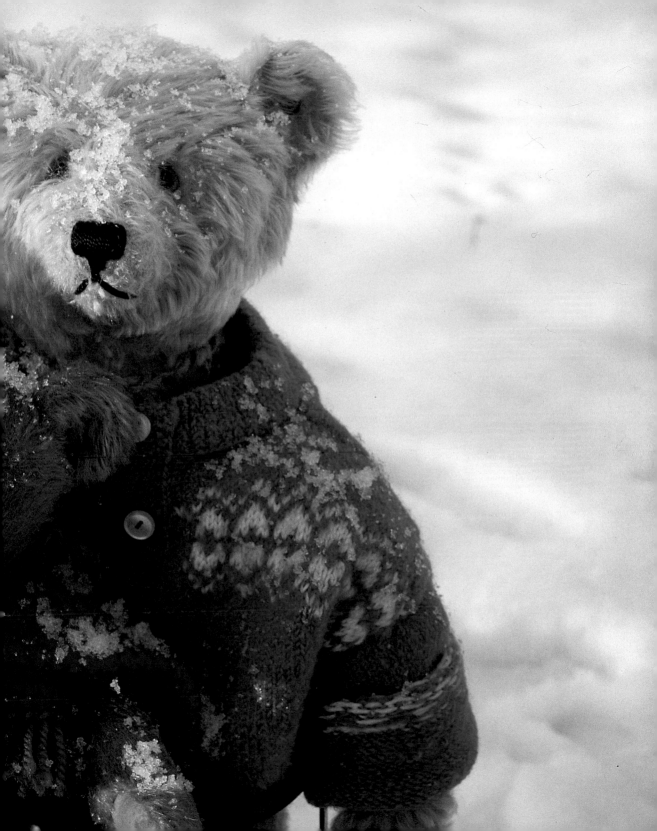

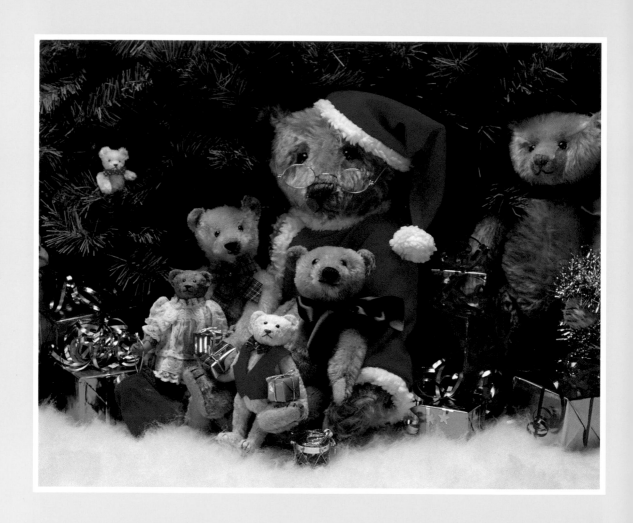

MEЯЯY X-MAS

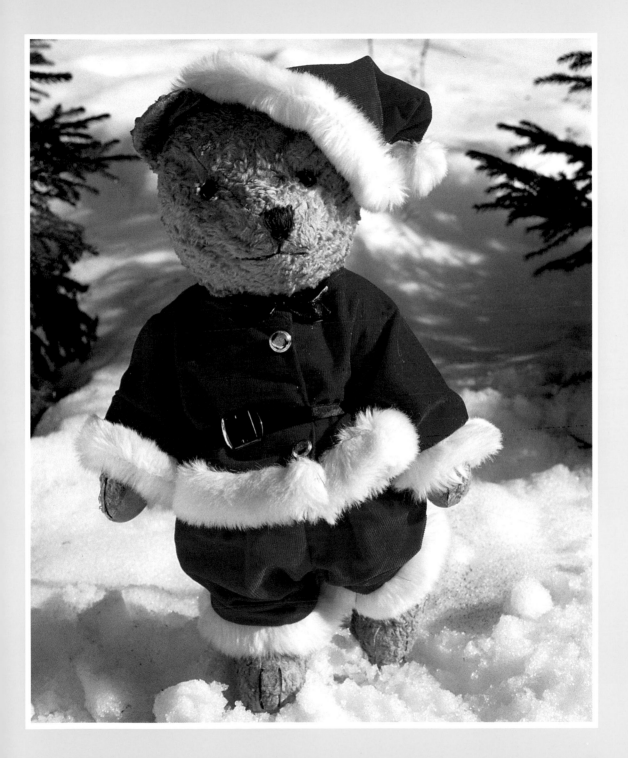

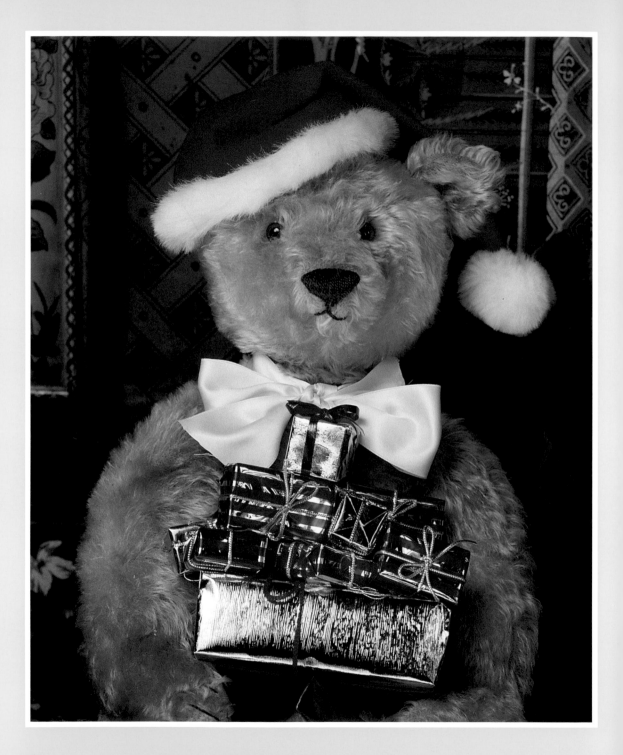

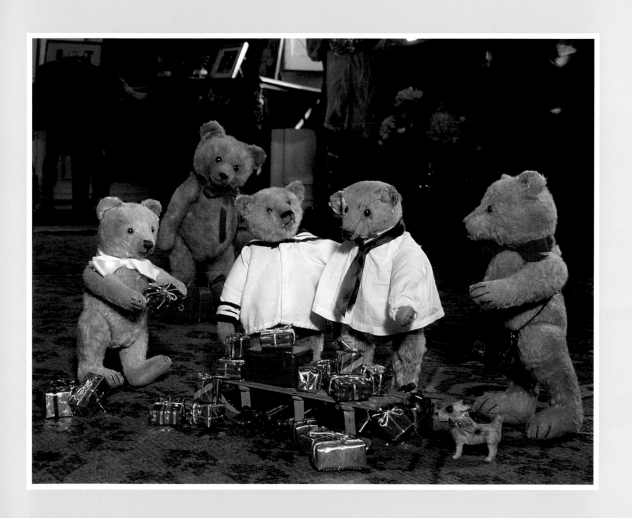

santa claus

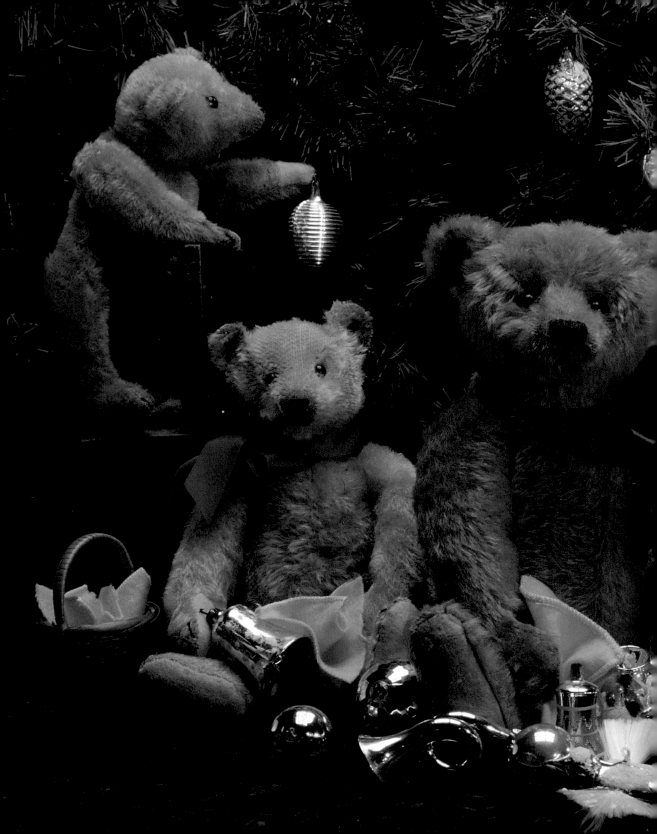

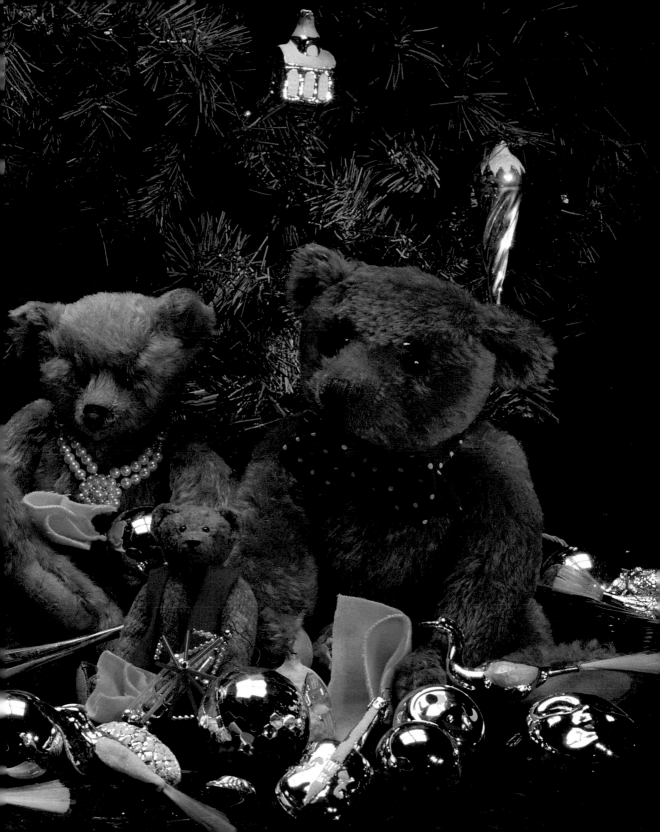

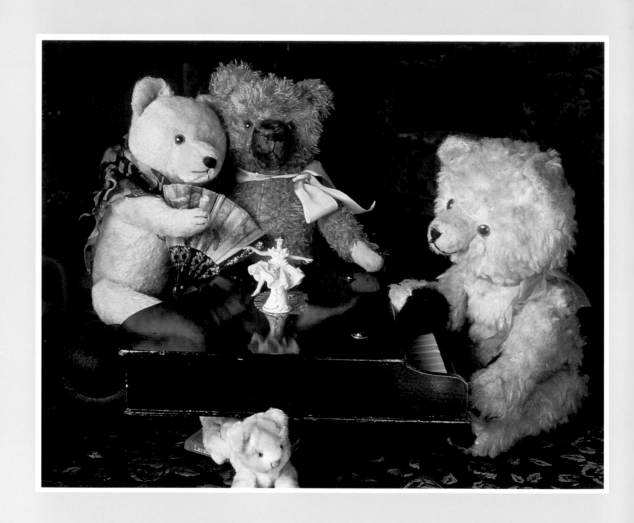

WE LOVE MUSIC

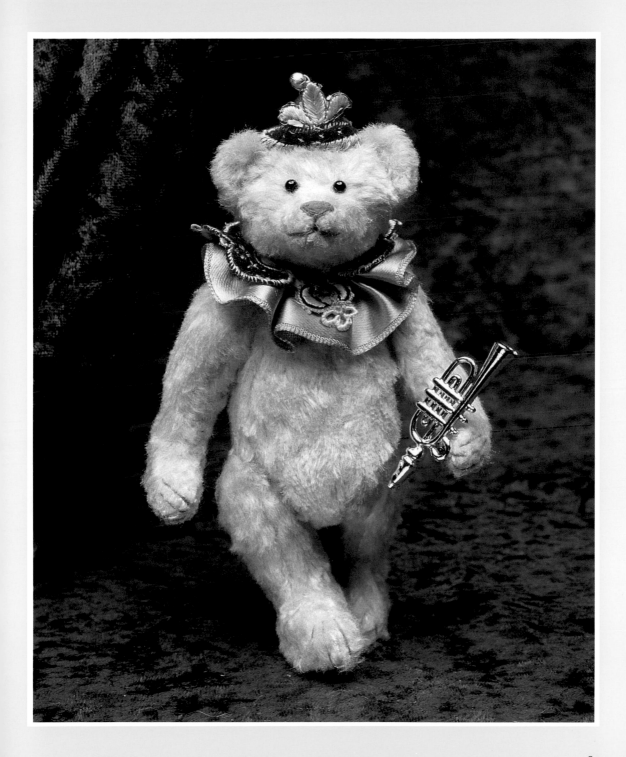

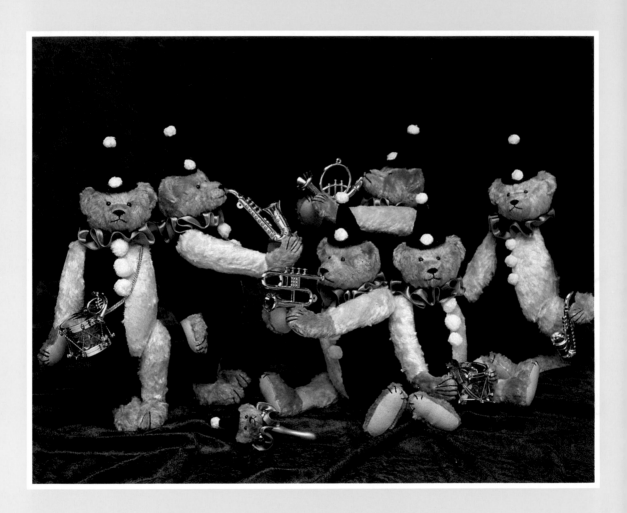

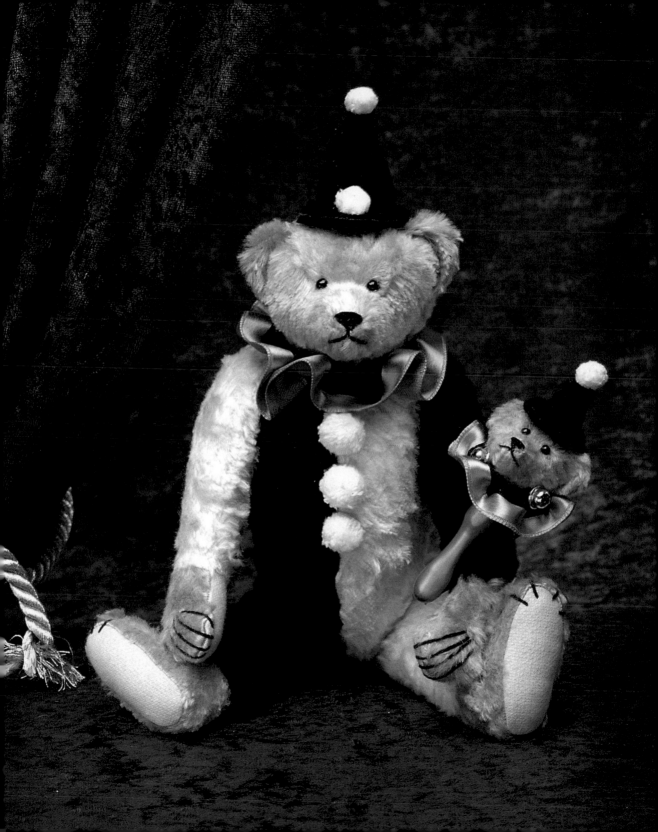

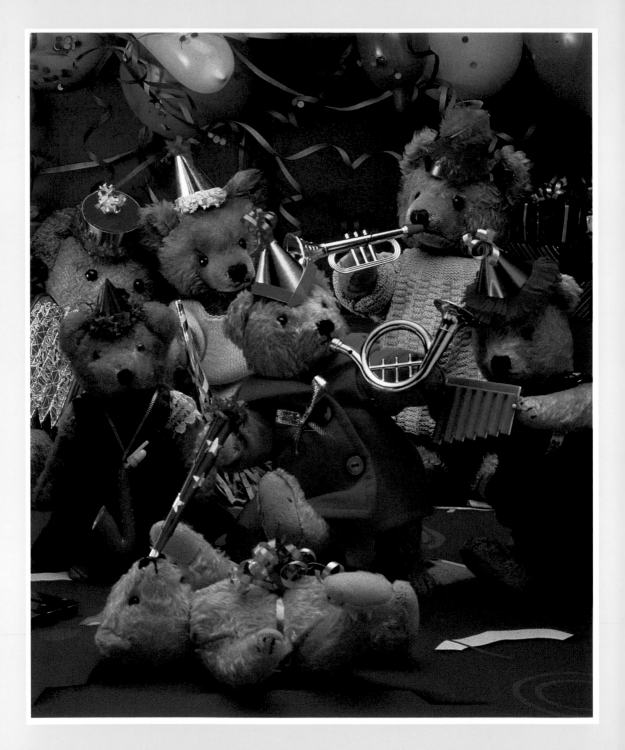

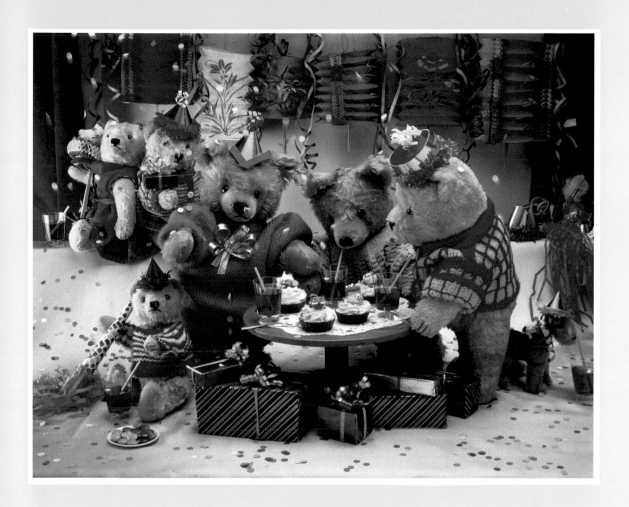

it's PARTYtime

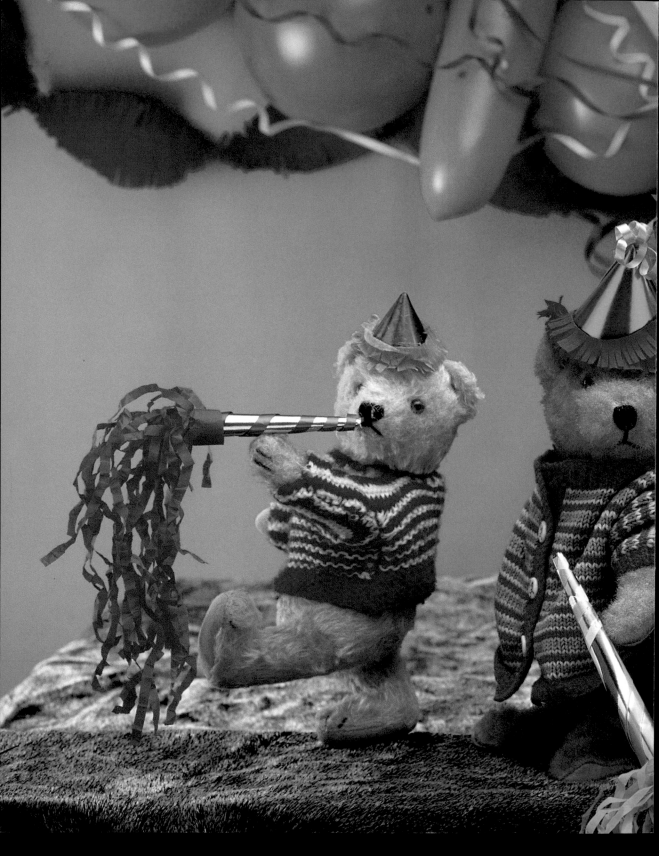

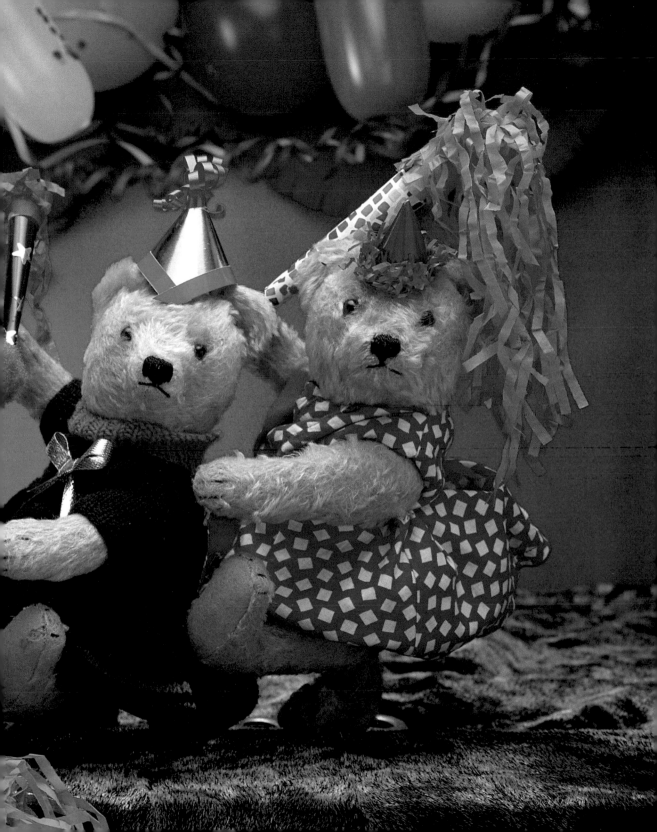

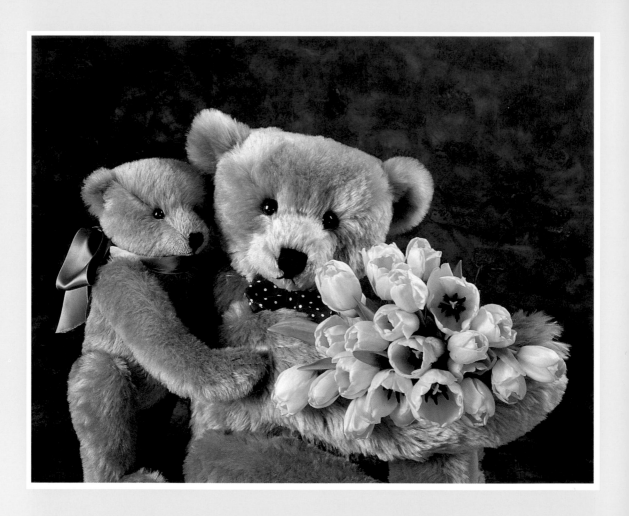

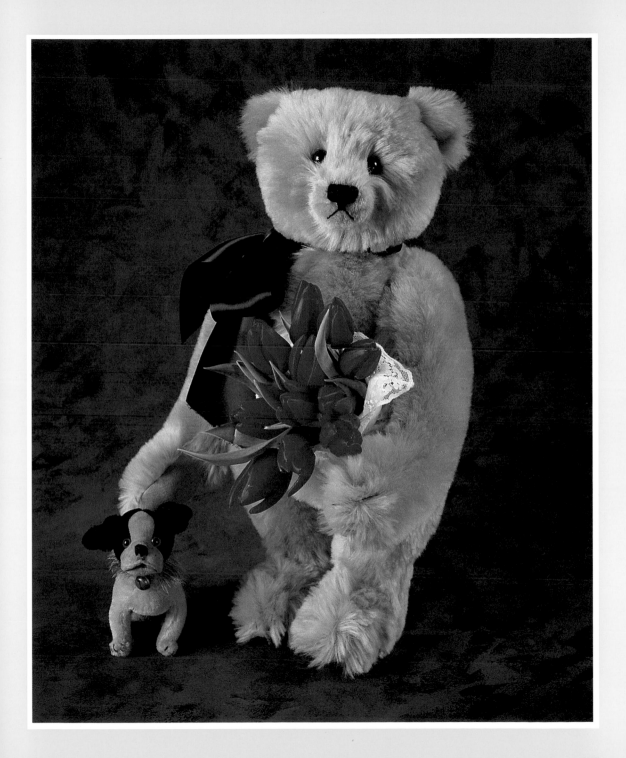

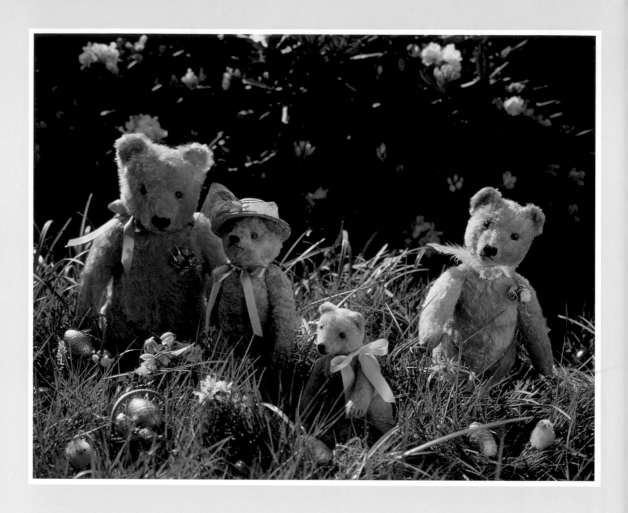

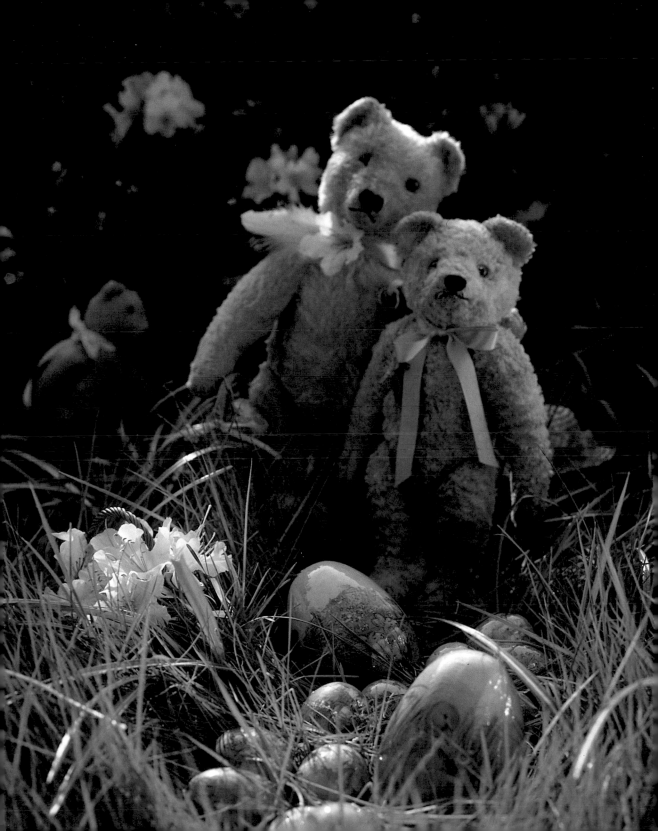

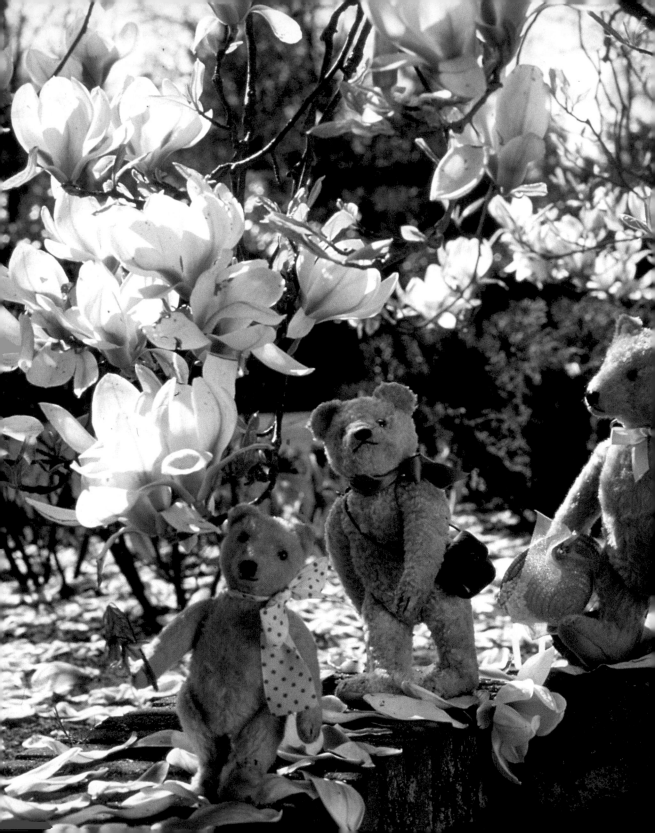

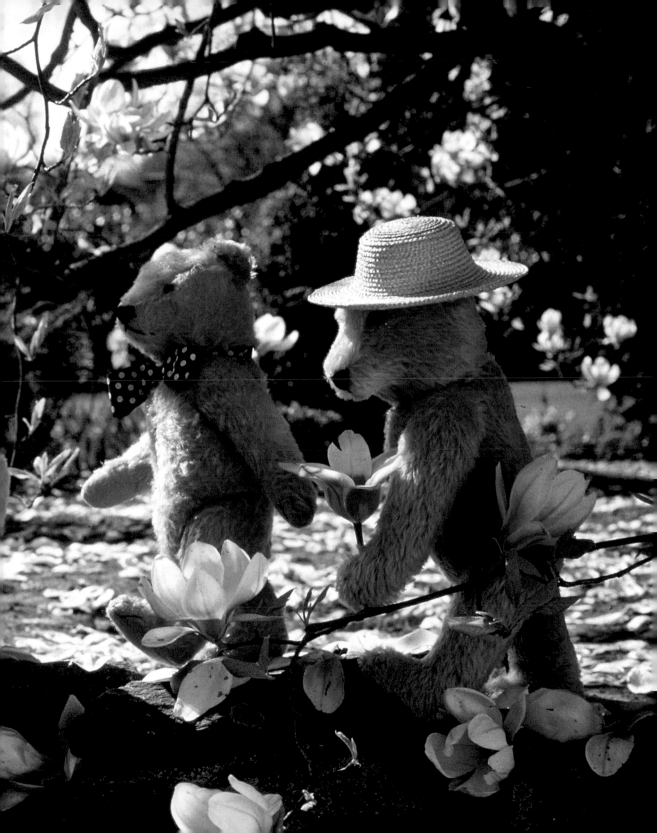

The publishers wish to express their particular gratitude to all the collectors
and designers who made their bears available for the photographs.

**Front cover** Collection Lyda Rijs-Gertenbach
**Front flap** Collection Hetty Vreugdenhil
**Inner front flap** Bears designed and handmade by John Stabbert
**Back cover** Collection Mirja de Vries
**Back flap** Saskia Voorbach
**Inner back flap** Collection Michel Kracht

**2-5** Collection Karin **7** Collection Mirja de Vries **9** Collection Karin **10** jan van der Wal **11** Collection
Saskia Voorbach **12** Collection Bas and Gerrie Schipper **13** Collection Lyda Rijs-Gertenbach **15** Collection
Annemiek van Leeuwen **16** Collection van Gelder **17** jan van der Wal **18** Collection Karin **19-20** jan van
der Wal **21** Collection Mea and Ben Jacobs **23** Collection Hetty Vreugdenhil **24** Collection Michel Kracht/
Lyda Rijs-Gertenbach **25** Collection Michel Kracht **28** Collection Mevr. Diepenhorst **29** Collection
Michel Kracht/Lyda Rijs-Gertenbach **30-31** Teddy bears staying at Amerongen castle, 1990 **32** Collection
Saskia Voorbach **33** Collection Els Roos **34-35** Teddy bears staying at Amerongen castle, 1990
**36-37** Teddy bear festival at Amerongen castle, 1991, Collection Kiok Siem **38** Collection Michel Kracht/
Lyda Rijs-Gertenbach **40-41** Teddy bear festival at Amerongen castle, 1991, Collection Bontekoe
**42** Collection Els Roos **43** Collection Karin **45** Collection Henk v. d. Vrande **46** Collection Mirja de Vries
**47** Collection Lyda Rijs-Gertenbach **48-53** Collection Mirja de Vries **54-55** Collection Mirja de Vries/Lyda
Rijs-Gertenbach **58** Collection Mirja de Vries **59** Big bear: Collection Akkerman **60-63** Collection
Mirja de Vries **64-67** Bears designed and handmade by John Stabbert **69-73** "Lyda's and Chrissie Bears"
designed and handmade by Lyda Rijs-Gertenbach, Holland **74-75** Collection Kiok Siem **76** Big bears:
Collection van Gelder; Little white and brown bear: handmade by Lyda Rijs-Gertenbach **77** Collection
Mirja de Vries **78-79** Collection van Gelder **80-81** Big bears: Collection van Gelder/Lyda Rijs-Gertenbach;
Little brown bear: handmade by Lyda Rijs-Gertenbach **82** Collection Maria B. de Vries **83** "Troupie Bear"
designed and handmade by Lyda Rijs-Gertenbach, Holland **84-85** "Noki Clowns Bears" designed and
handmade by Lyda and Nico Rijs, Holland **90-91** "Sunny Bears Holland" designed and handmade by
Anne-Marie van Gelder **92–95** Collection van Gelder

© 1998 Benedikt Taschen Verlag GmbH
Hohenzollernring 53, D–50672 Köln
Photos: Mirja de Vries, Amsterdam
Edited by Ute Kieseyer, Cologne
Design: Catinka Keul, Cologne

Printed in Spain
ISBN 3-8228-7878-2